ZEN DOODLE

oodles of Doodles

edited by

TONIA JENNY

NORTH LIGHT BOOKS
Cincinnati, OH
CreateMixedMedia.com

contents

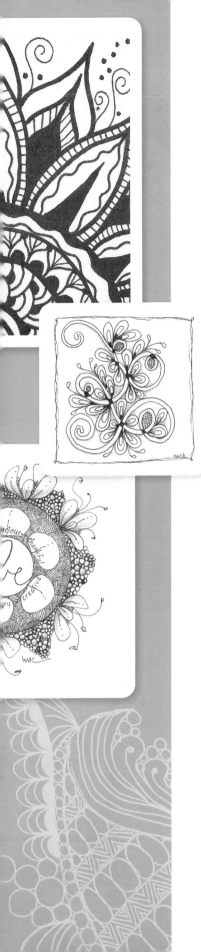

what you need

Surfaces
140-lb. (300gsm) mixed-media paper, vellum surface

140-lb. (300gsm) watercolor paper

140-lb. (300gsm) watercolor tile

200-lb. (425gsm) smooth paper

2-ply vellum bristol tile

60-lb. (130gsm) charcoal paper

93-lb. (200gsm) paper

artist marker pad

artist tiles

bristol artist tiles, 100-lb. (215gsm) vellum surface

bristol board, white

bristol paper including 88-lb. (190gsm) white cover, 96-lb. (205gsm) smooth, 100-lb. (215gsm) with vellum surface and 110-lb. (235gsm)

canvas

card stocks: glossy, heavy, 80-lb. (170gsm) smooth white, 110-lb. (235gsm) white

cartridge paper, thick white

doodle cards, square

drawing paper

ephemera (e.g., old dictionary page)

fine artist's paper, 100% cotton, heavy-weight, vellum finish

foamboard

mixed-media paper

multimedia art paper

paper, gray

plastic matte film

postcard, blank

printmaking paper

scrapbook paper

sketch pad paper

sketchbook paper

toned sketch journal

watercolor paper

zentangle tiles: tan, white and apprentice

Drawing Tools
assorted pens

assorted pencils

chalks

markers: fine-point et al, black, glitter, metallic & assorted colors

Other Supplies
acrylic paints

angle and circle protractor

blending stump

color wash ink sprays

computer software: Android HP Touch-pad & Sketchbook Pro by Autodesk

craft foam

craft knife

decorative punch

drafting compass

erasers: white plastic, etc.

Gelli plate

oil pastels, water-soluble

paintbrushes

ruler

sandpaper

spray fixative

stencils (optional)

tortillion

watercolors

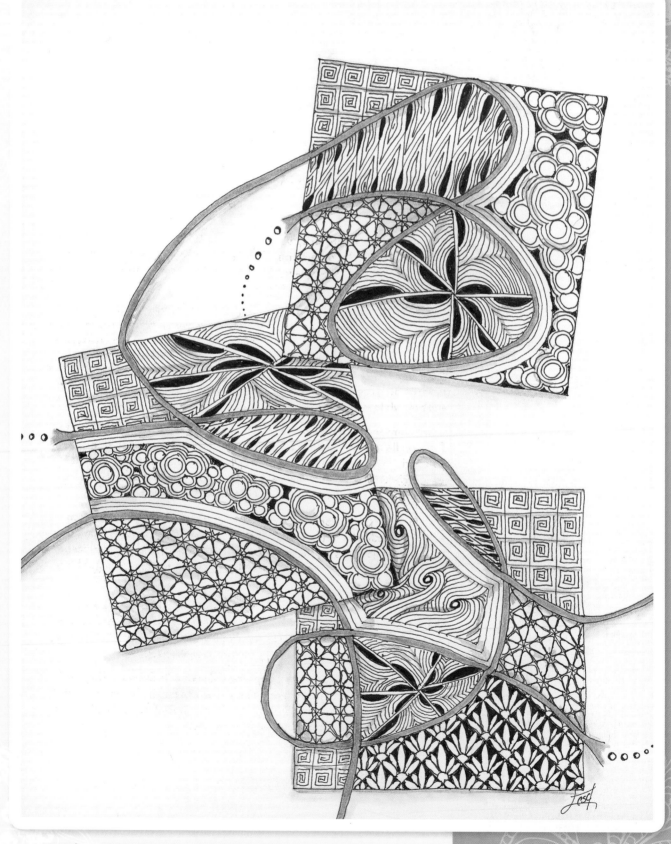

BREAKING FREE
CATHY CUSSON

introduction

Welcome! I hope you've rounded up your favorite mark-making implements and sufficient paper, tiles or other surfaces to work on, because the inspiration you're going to find on these pages is going to make it difficult to resist diving right into the Zen Doodle zone!

I'm guessing you're already aware that the act of doodling holds more value than a finished work, and if you haven't discovered that secret already, I'm confident you'll agree after your first experiment. You see, the reason we all adore this process is that it needn't be about improving your skill (though this can certainly happen naturally through repetition) or about trying to reach some lofty artistic goal. It's about relishing where you are right here and now while everything else fades away.

Brittany and I are very excited to bring you this wonderful collection of Zen Doodle art. We handpicked the most visually yummy pieces in the hope of inspiring you to try taking your doodling in new directions. Many great artists from the first Zen Doodle book have returned with great new works, and we're also thrilled to introduce you to several new artists.

The first and heftiest section of the book features a wide variety of Zen Doodle art to get your wheels turning and to serve as a jumping-off point for your own doodles. Each artist in this section has broken down their process into three stages or steps to make it easier for you to see how they got from start to finish.

The second section includes a close-up and personal look at nine Zen Doodle artists who share themselves with us, offering a look at what inspires them, what their favorite materials are and why they love to doodle. (Though those of us who've tried it are pretty sure we already know!)

We hope you enjoy perusing the pages of *Zen Doodle Oodles of Doodles* and use it as an inspiring tool during times when the blank tile seems daunting. Most important, as contributing artist Deborah Pacé says, "Don't stress about it, don't overthink it; just have fun and play."

Enjoy!

—Tonia and Brittany

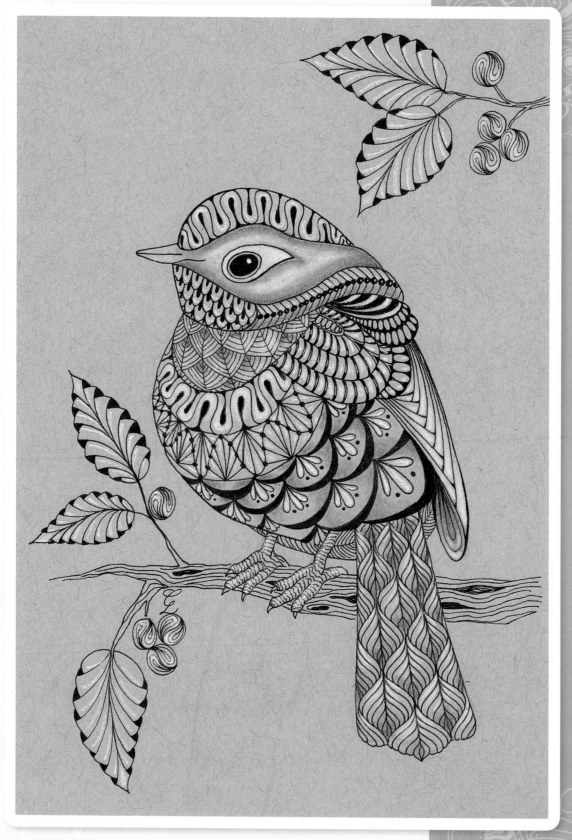

Little Flycatcher
CATHERINE LANGSDORF

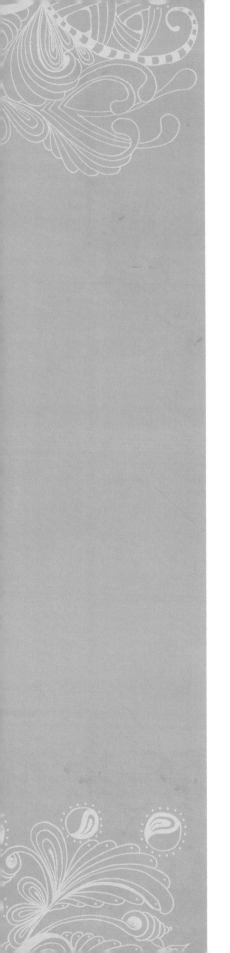

part one ∽

zen Doodle inspiration

We've selected over forty artists and more than ninety beautiful Zen Doodle works to inspire you in this first jam-packed section. Each artist happily shares the thought that went into each piece and a short series of steps to illustrate how their works were created.

The variety here is great, with works ranging from abstract compositions to letterforms, animals, subjects of nature and expressions of favorite things. While most works are in classic black-and-white, many artists chose to add color to their pieces—at times just a little and, at others, a lot.

Whatever direction excites you the most, we hope you'll be inspired to go outside your comfort zone and try something new. You're bound to discover a new perspective here. Let the inspiration begin!

spherical reflection
ABI FULLER

10" × 10" (25cm × 25cm)
*Single-layered black ink screen print
on thick white cartridge paper*

I like to think of my work as a
combination of the crazy ideas
that pop into my head and my life
experiences. Zen Doodling appeals
to me because the final artwork is
often nothing like what I'd pictured
to begin with!

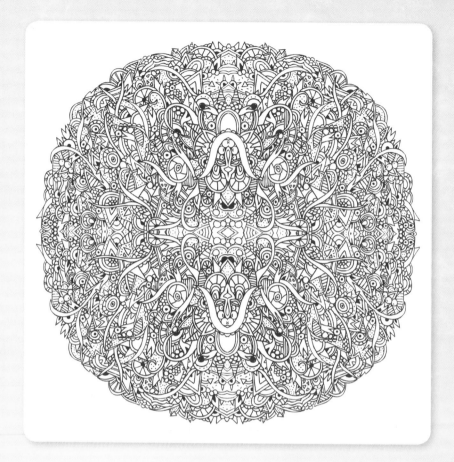

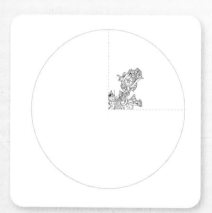

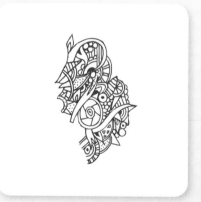

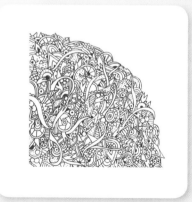

1 Using a pencil, begin by sketching
a rough quarter of a circle shape
to contain your doodle.

2 Using a thin black fineliner, be
imaginative and draw a variety of
shapes such as triangles, circles
and other organic forms.

3 Scan your drawing into a
computer and reflect the segment
four times. This will give you a
precisely circular reflected form.

Sign up for our inspiring and free newsletter at CreateMixedMedia.com.

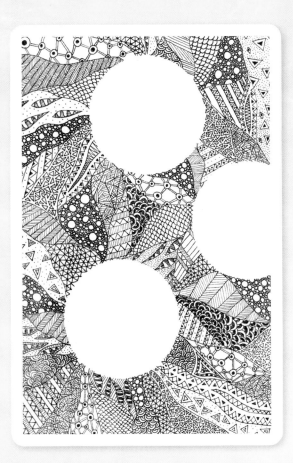

patchwork

ABI FULLER

8" × 12" (20cm × 30cm)
Black Stabilo 0.4mm fineliner on white cartridge paper

For this piece I was inspired by the designs of patchwork quilts with their mismatch of patterned material. A good Zen Doodle takes time and patience, so don't rush your line work—even if your hand is tired. Just take a break!

take every opportunity presented to you in life, because they will always come back to help you in the future!
—ABI FULLER

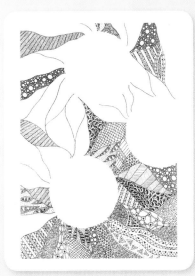

1 Begin by drawing a series of shapes on your page in pencil. These shapes will be the negative space where no drawing will occur.

2 Use wavy lines to divide the page into sections and fill each one with a different pattern. Try not to use similar patterns next to each other.

3 Include a lot of detail to make your doodle more interesting, and take your time to plan ideas on scrap paper before starting.

cornucopia
ALICE HENDON, CZT

3½" × 3½" (9cm × 9cm)
Sakura Pigma micron 01 pen on 100% cotton, heavy-weight fine artist's paper with a vellum surface finish shaded with a Copic marker.

Combining various tangle patterns into works of art gives me focus and purpose. However, finding a starting point can be difficult. Sometimes I challenge myself by closing my eyes and drawing a looping, swirling line on the paper without looking. Then I begin tangling what my heart sees when I look at the lines. I encourage you to do the same whenever you're in a Zen Doodling rut.

то draw, you must close your eyes and sing.

—PABLO PICASSO

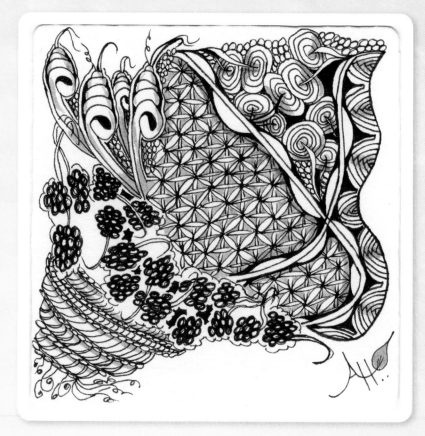

visit createmixedmedia.com/zen-doodle-oodles-of-doodles
for some bonus step-by-steps from this artist!

1 With pencil in hand, close your eyes and draw a continuous, random line on your paper. Your line can be curvy and swirly or straight and linear. This line is going to loosely divide your tangles.

2 In one section, draw alternating bands of small circles and arcing double lines.

3 Along part of the dividing line, draw half moons and smooth out the hard corners with curves filled with ink.

Sign up for our inspiring and free newsletter at CreateMixedMedia.com.

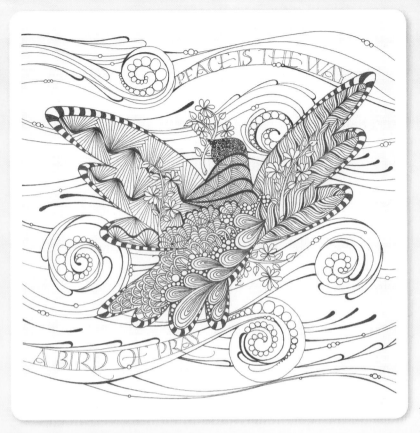

Bird of Pray
CATHERINE LANGSDORF

8½" × 8½" (22cm × 22cm)
Sakura Pigma micron 01 and 005 pens and soft pencil on bristol paper

This piece started with the outline of Pablo Picasso's *Dove of Peace*. After completing the border of the dove, I randomly placed patterns inside it. I enjoy the process of reacting to the lines and making design decisions while in the creative zone. I am amazed—and usually pleased—at how something unplanned turns out. I find that this style of art goes a far way to bolstering my artistic confidence.

Art and these types of art pieces can be a wonderful spiritual journey if you silence yourself and pay attention.

—CATHERINE LANGSDORF

1 Start with the outline of the focal image. Add a strong pattern to create an outline of the shape that will set the image apart from the detailed background. For this piece, I chose a simple stripe but made sure to curve each one to help give depth to the image.

2 Add any additional elements that other patterns will need to work around. In this image, I wanted some olive branches to help carry out the theme of peace.

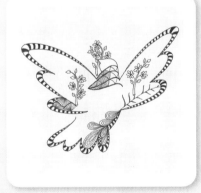

3 Fill in the main image with various patterns. For a harmonious texture, stick with doodles that are similar and are created with curvy lines. To achieve gentle transitions within the design, let one pattern build upon the previous pattern without harsh divisions.

eye spy
ALICE HENDON, CZT

3½" × 3½" (9cm × 9cm)
*Sakura Pigma micron 01 pen,
Derwent Inktense pencils,
Faber-Castell Pitt artist pens,
Copic Atyou Spica pens
on 100% cotton, heavy-weight fine art-
ist's paper with a vellum surface finish*

I was experimenting one day,
drawing different variations of
grass, and before I knew it, these
fun little guys just appeared among
the blades. I realized they were
taking on the appearance of people
and critters, so I just ran with it.
I gave them little hats that are
combinations of a couple different
tangles, and was it ever fun! I see
two humans and at least a couple of
critters. Can you find them?

*never let anyone dull
your sparkle.*

—ALICE HENDON , CZT

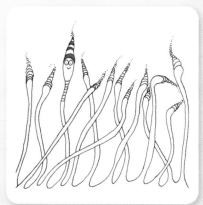

1 Draw a series of waving, wiggling
and wormy grasslike shapes
across the bottom. They can
overlap or cross behind one
another. Make the top of each
blade a bit round and bulbish.

2 Layer a series of curved arcs
atop each bulb, going from
larger to smaller in size. These
will have the appearance of
stocking caps.

3 Look at each of the blades.
What do you see? Can you
spot a person? Can you spot a
critter? Embellish accordingly
and have fun! (In my example
I see Harry Potter, Waldo, a
flamingo and a worm.)

Sign up for our inspiring and free newsletter at CreateMixedMedia.com.

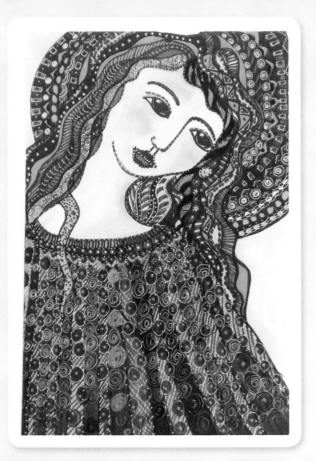

Grace
AMANDA TROUGHT

11" × 8" (28cm × 20cm)
Pen and ink, ProMarker pens, metallic markers on watercolor paper

I have always been interested in drawing faces of iconic religious images and wanted to capture one while using Zen Doodling elements. While drawing a simple image, the beauty begins to come out as different patterns are added. Because of the detail, it is important to break it down and create multiple layers. Doing this allows your art to become a great therapeutic activity as you move from one section to another.

shine your light on the world each and every day.
—AMANDA TROUGHT

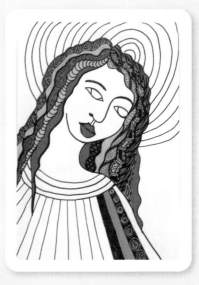

1 Begin with a very simple pencil drawing (your choice). It helps to think about the process in layers—adding as much or as little as you wish.

2 Using a black pen, go over your pencil lines. Add extra lines or patterns where you feel inspired, and make some lines thicker than others. Try adding bright colors to random areas that will later be highlighted as you go over them with a black pen.

3 Start adding shapes to your image. Then add the halo around the head area and a design on the dress.

under the sea
MARIA MERCEDES

3½" × 3½" (9cm × 9cm)
white bristol board
Sakura Pigma Micron 02 and 03
pens in black on tile

For this title I was inspired to create
the underwater world of a mermaid.

*walk in the direction
of your dreams. They
are waiting for you to
claim them.*
—MARIA MERCEDES

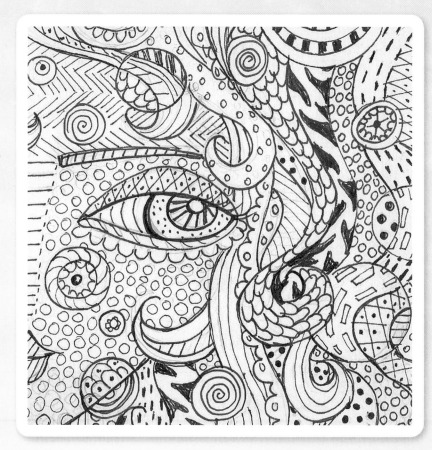

1 With a pencil, lightly draw half
 of a head and a face on the tile.

2 Begin laying out her wavy hair with
 a free-motion movement, as if
 simulating the waves of the ocean.

3 Add different-sized bubbles and
 fill them in with your favorite
 doodles and patterns. Once
 the drawing is complete, use an
 eraser to remove all pencil lines.

Sign up for our inspiring and free newsletter at CreateMixedMedia.com.

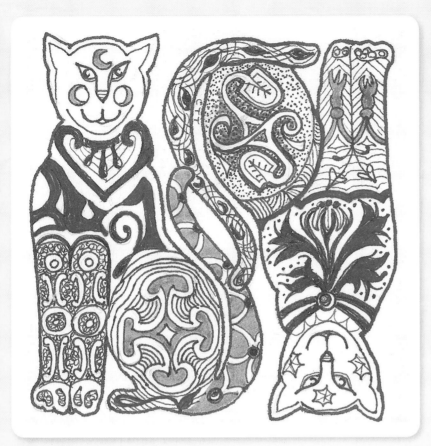

upside down cats
CANDY TAYLOR TUTT

3½" × 3½" (9cm × 9cm)
*Fine-point markers on Strathmore
400 watercolor paper tile*

Since we have numerous cats
lounging about the house, I focused
on doodling a cat silhouette. Then I
decided to arrange two images in a
yin-yang layout.

*Life is too short—
go make art and enjoy
yourself.*
—CANDY TAYLOR TUTT

1 Draw a template on glossy
cardstock. Make sure it fits
inside one half of the tile space.
After cutting it out, carefully
trace it onto the paper using
a no. H pencil. One should be
right-side up and the other
upside down. Their tails should
meet in the middle.

2 Go over the outline using a pen
or marker.

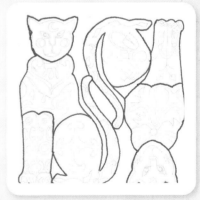

3 With the pencil, draw details
inside the cat outlines. Use
spirals, borders and various leaf
patterns for inspiration. Then
use pens and markers to ink
everything in.

Hearts
ANNIE SANDERSON

3½" × 3½" (9cm × 9cm)
*Sakura Pigma micron ink and pencil
shading on Zentangle tile*

What do Valentine's Day and a
Zentangle class have in common?
They were the theme and inspiration
that motivated me to create *Hearts*. I
created this design using some of the
techniques and tangle patterns that
were introduced to me in this seren-
dipitous art class on Valentine's Day.

*Every artist dips his
brush in his own soul
and paints his own
nature into his pictures.*

—HENRY WARD BEECHER

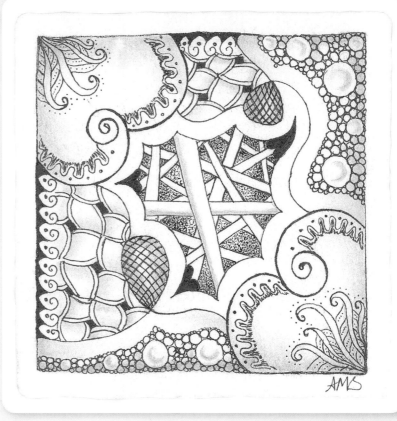

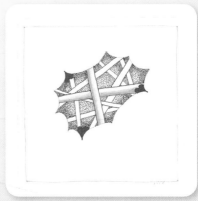

1 Using a soft no. 2 pencil, lightly
mark four corners with dots.
Connect them to create the
border of the tile. Within the
border, draw random string
designs by creating hearts in
opposing corners.

2 With a micron 03 pen, darken
the hearts. For the center of
the design, create a Hollibaugh
pattern. Start in the foreground
and work toward the background,
drawing lines to form cylinders
that go in different directions.
Make them as wide or narrow as
you desire.

3 Using a micron 01 pen, fill the
background with dots, starting from
the corners until the whole area
behind the cylinders is covered.
Repeat the process in random areas
for a darker effect. With a no. 2 soft
pencil, shade one side of the two
top cylinders for depth.

Sign up for our inspiring and free newsletter at CreateMixedMedia.com.

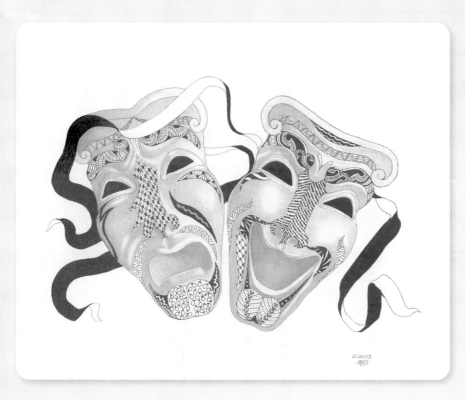

comedy–tragedy zen masks
ANNIE SANDERSON

11" × 14" (28cm × 36cm)
Bristol vellum surface
Sakura Pigma micron ink and
pencil shading

Greek theatrical masks are well-known in the world of art and were used in ancient plays to express the characters' emotions. As I began experimenting with the different tangle patterns, I thought adding doodles to the masks would create a dramatic effect. The combination of black and white, the detail in the variety of these unique patterns and the shading combined to add great theatrical depth.

The aim of art is to represent not the outward appearance of things but their inward significance.
—ARISTOTLE

1 Lightly border the tile with a no. 2 soft pencil and draw the outline of the mask with a micron 03 ink pen. Also outline different areas on the mask where you want to draw additional tangle patterns.

2 Using a micron 01 ink pen, start designing the initial curve of the scallop pattern for the eyebrows. The scallops should be facing the same direction.

3 Continue to add different lines and small circles on top of each scallop. Finish by darkening the smallest part of each scallop.

in bloom
ANNE GRATTON

3½" × 3½" (9cm × 9cm)
Black Faber-Castell pens on a Zentangle tile

The inspiration for this tile was spring! We had trees budding out and flowers popping up in our yard. Flowers are wonderful things, aren't they? All those beautiful colors and shapes—they make me happy!

some people think they won't like zen doodling, but once they give it a try and see how much fun and how relaxing it is, they're hooked!

—ANNE GRATTON

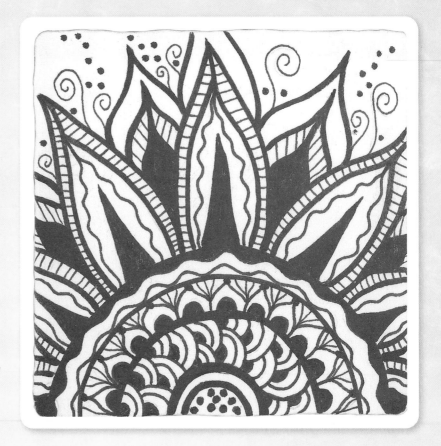

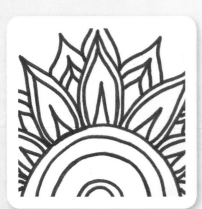

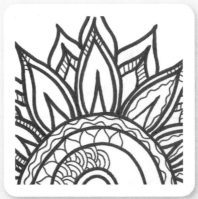

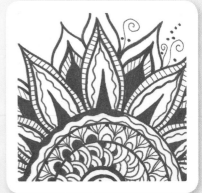

1 In pencil, lightly draw the flower design on the tile. Carefully go over the pencil lines using a B size pen.

2 Using an M size pen, start drawing in the patterns. Remember to use the size point tip that best fits the space, e.g., a smaller tip for smaller spaces.

3 Fill in the large shapes of the petals and dots with the B size pen. Then add the swirly lines with an S size pen. Erase any pencil lines that are left.

Sign up for our inspiring and free newsletter at CreateMixedMedia.com.

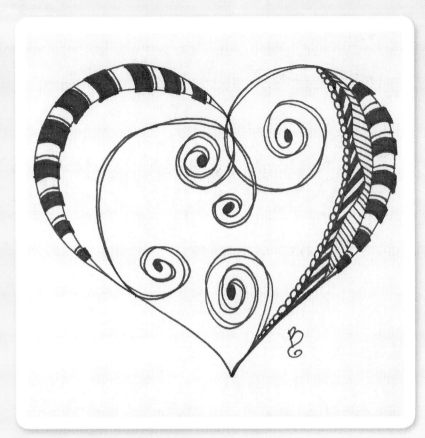

HEART DOODLE
BRENDA CAMPBELL

4½" × 4½" (11cm × 11cm)
Faber-Castell Pitt artist pen on multimedia art paper

I have always been inspired by hearts, so it was only natural for me to use heart shapes for my doodling. The tangles I used in this doodle were inspired by happy accidents. The whimsy-curl is a curly shape that I love and use often. I wanted to add to it, and although I really had not planned it, the second line naturally crossed the first to create an interesting, whimsical, ribbon-looking tangle.

when I stopped judging myself, I found the freedom to love my doodles.
—BRENDA CAMPBELL

1 Start with a heart shape. Add curls to your design.

2 Add a second line to the curls. The second line should cross the first to make a ribbon-like shape.

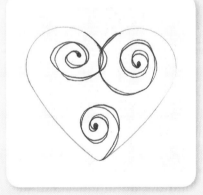

3 Add more curls and tangles to complete your doodle.

zentangle bird series – flying

BARBARA KAISER

8" × 10" (20cm × 25cm)
Sharpie fine-point pen,
no. 2 mechanical pencil,
Primo Elite Grande #5000
charcoal pencil on bristol
110-lb. (235gsm) paper

I am drawn to the challenge
of transforming a collection
of lines into a three-dimen-
sional drawing by adding
various shading techniques.
I pencil in the image and
the basic textures, which
allows me to decide what
portions of the work will be
in the foreground and what
will be behind.

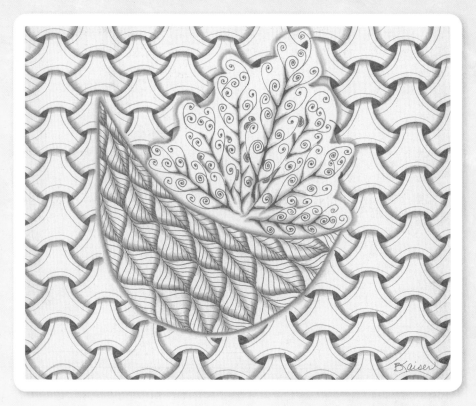

*Life is a succession of lessons, which
must be lived to be understood.*

—RALPH WALDO EMERSON

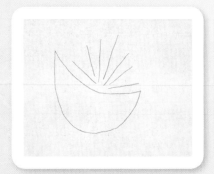

1 Pencil in the image.

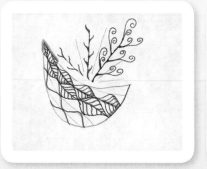

2 Draw branches on the tail feather.
Fill in the base of each branch.
Add embellishments. Pencil in
lines along the body. Draw wavy
lines between the parallel lines.
Draw S lines from the inside of the
leaf to the outside. Add shading.

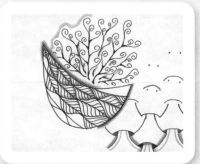

3 Pencil in alternating pairs of dots.
Draw arches over the dots. Draw
curved lines between the dots
and the arches. Extend the lines
to complete the shapes. Add
embellishments and shading.

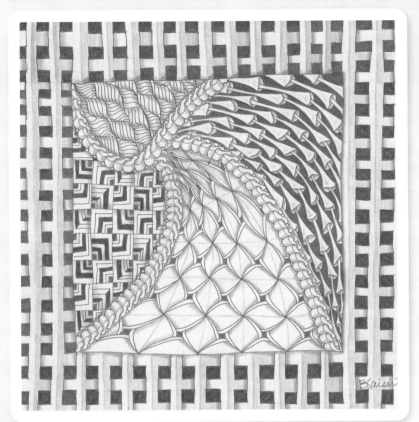

spiralinks

BARBARA KAISER

10" × 10" (25cm × 25cm)
Sharpie fine-point pen, no. 2 mechanical pencil on 60-lb. (130gsm) surface

I create graphite and charcoal drawings and began working with Zen Doodle methods as a drawing exercise. When I realized how meditative and creative this art is, I now turn to this method to help me better envision more artistically.

whether you think you can or think you can't— you're right.
—HENRY FORD

1 Begin by drawing a line of cursive Cs. Draw a curved line connecting the top of one C to the next. Draw a straight line down from the inside of the C and a curved line connecting the straight lines. Add embellishments and shading.

2 Draw a grid. Put a small filled square in this pattern, moving across left to right, upper left, bottom left. Next row, reverse it, upper right, bottom right. Add random L shapes to each box and randomly fill them in or add thicker lines. Add shading.

3 Pencil in a grid, then fill in every other square. Working top to bottom, draw a line on the left side to connect every other box. Move to the next row on the left and down to connect every other box. Pencil in the center of each row from top to bottom and add shading.

zentangle ʙɪʀᴅ series – singing

BARBARA KAISER

8" × 10" (20cm × 25cm)
Sharpie fine-point pen,
no. 2 mechanical pencil,
Primo Elite Grande #5000
charcoal pencil on 110-lb.
(235gsm) paper

I find my eye drawn to interesting art in the backdrops of television shows, magazines and newsletters. The *Bird Series* was an inspiration from kitchen artwork that peeked from behind an actor. I then started envisioning positions birds could take during the day and drew outlines of those positions.

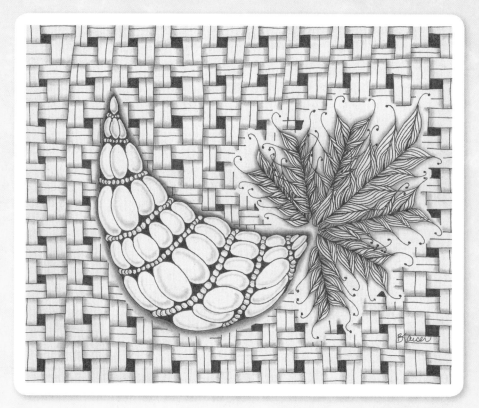

ᴘerfection is a mean, frozen form of ıdealısm, while messes are the artist's true friend.

—ANNE LAMOTT

1 Pencil in the image.

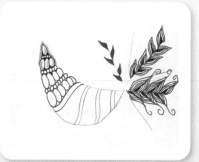

2 Pencil in parallel wave lines, alternating thin and thick. Draw ovals along the thick spaces and circles along the thin spaces. Ink in the gaps between the shapes and shade the ovals. Draw single small feathers and partially outline them. Add embellishment and shading.

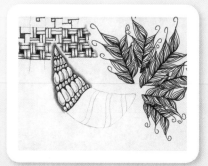

3 Draw a grid. Add small squares to each box. Working from left to right, extend a line across the top of the square to the right line of each box. Rotate the paper tile clockwise to continue the pattern. Add embellishment and shading.

Sign up for our inspiring and free newsletter at CreateMixedMedia.com.

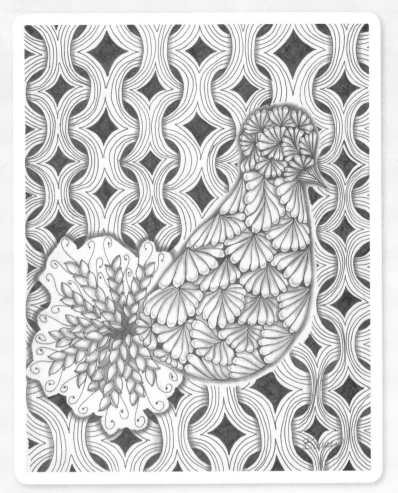

zentangle bird series – resting

BARBARA KAISER

10" × 8" (25cm × 20cm)
Sharpie fine-point pen, no. 2 mechanical pencil, Primo Elite Grande #5000 charcoal pencil on 110-lb. (235gsm) paper

Nature is my favorite subject to draw. The patterns of butterfly wings, flower petals and seashells are so intricate. I am fascinated with turning complicated features, such as feathers, into textures that look very complex but are simple to create.

The greatest pleasure in life is doing what people say you cannot do.

—WALTER BAGEHOT

| Pencil in the image.

2 Draw connecting arches along the tail feather. Connect the tip of one arch to the arch below. Add embellishments and shading.

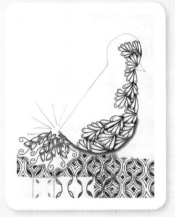

3 Draw scallop fans and parallel lines to connect the scallop to the center. Add shading and pencil in a grid. Draw seeds in each corner of a box. Connect the upper left seed to the lower left seed, then repeat on the right side. Add embellishments and shading.

directions
BARBARA SIMON SARTAIN

3½" × 3½" (9cm × 9cm)
Micron pens on Strathmore Pearl White 88-lb. (190gsm) cover bristol tile

After researching historic designs and motifs from around the world, I realized that we doodlers are creating our own versions. Picking up on some of their simple but ornate styles inspired me to create this mandala.

once you master silencing the outer noise, you can create your own.

—BARBARA SIMON SARTAIN

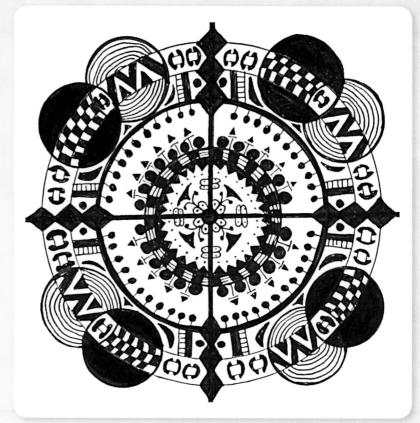

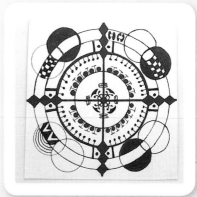

1 Divide your tile into four equal sections to create a center point. Then, using an angle-and-circle protractor, draw several circles around this point.

2 Start adding more elements of interest to your design with more circles around the perimeter.

3 Fill in the remaining empty space with repetitive designs or a variety of patterns.

Sign up for our inspiring and free newsletter at CreateMixedMedia.com.

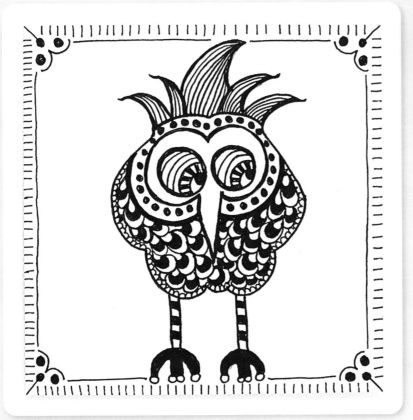

clyde
BARBARA SIMON SARTAIN

3½" × 3½" (9cm × 9cm)
Micron pens on Strathmore Pearl White 88-lb (190gsm) cover bristol

I love anything that's whimsical or quirky, and Clyde is just that! He's always on the lookout for fun and happy doodlers!

No matter how old or young, creating your art makes a happy heart.
—BARBARA SIMON SARTAIN

| Start with a silly outline for your bird. Next add the eyes, beak and legs.

2 Create a border and start adding details.

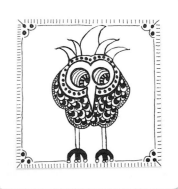

3 Continue filling in patterns in the body, legs and head.

tangle within a tangle
DEANNA CLIFFORD

3½" × 3½" (9cm × 9cm)
*Sakura Pigma micron pen 01 black
and Staedtler 2B pencil on 140-lb.
(300gsm) Strathmore mixed-media
paper, vellum surface*

The inspiration for this tile came to
me by happy accident. *Fiore* means
flower in Italian. When linked together
in a series, the Fiore tangle creates a
flower. Filling in the petals, created
by linking the four Fiore tangles,
provides the opportunity to try a
variety of tangles within the tangle.
As a gardener, I am drawn to tangles
that capture the spirit of nature,
whether leaves, flowers or vines.

*Believing that you
can is the most
powerful gift you
can give yourself.*

—DEANNA CLIFFORD

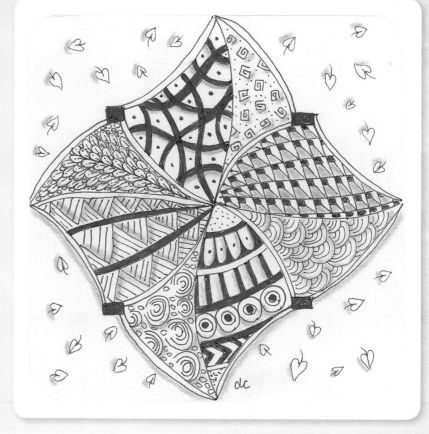

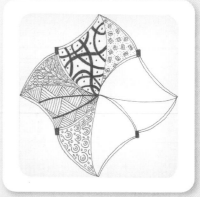

1 | Begin by drawing four quadrants
within the tile. The center of
the Fiore tangle should be in
the center of each quadrant.

2 | Outline the Fiore and add
double lines to create dimension
in the outline of the flower.
Additional lines from the center
to the farthest point provide
the opportunity for more petals
(and more tangles) in the flower.

3 | Select tangles for each of the
eight petals of the flower. Add
depth to the design by shading
the outside edge of the tangle
and spaces within each tangle.

Sign up for our inspiring and free newsletter at CreateMixedMedia.com.

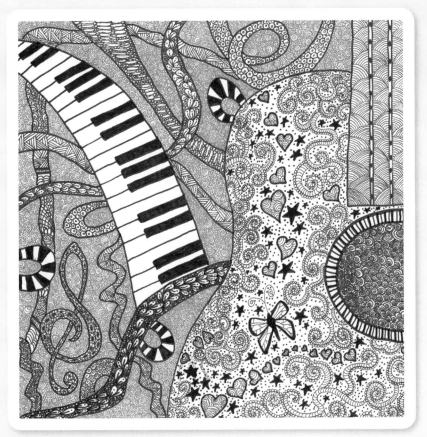

in the key of doodle
COLEEN PATRICK

12" × 12" (30cm × 30cm)
Pencil, fine-point black Sharpie marker, extra-fine Recollections pen in black, red Millennium drawing pen 05 on scrapbook paper

My inspiration for creating this design was my music-loving, guitar-playing sister. I thought of my work space as an album cover, drawing doodle patterns as well as adding elements personalized to my sister, such as the butterfly.

curiosity and the courage to remain open to possibility can lead to happy discoveries.
—COLEEN PATRICK

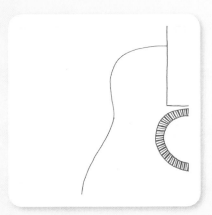

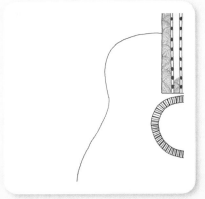

1 | Create in pencil a basic outline of a guitar. Once drawn, go over the line with a fine-point black marker.

2 | Draw inside one of the shapes with an extra-fine point pen. I started in the corner of the neck, drawing curved lines that build on one another.

3 | Draw spirals in varying sizes until the space is filled. Continue filling the page with your favorite patterns.

zen colorwheel

CATHERINE LANGSDORF

8½" × 8½" (22cm × 22cm)
Sakura Pigma micron pens 01 and 005 and colored pencils on bristol paper

This piece was created as a personal challenge. I love the color wheel format, so I wanted to blend that with a mandala structure filled with line patterns. This piece contains eight patterns plugged into sections. Once the black line work was completed, I used six colored pencils to create a blended color wheel.

silence the inner critic and put pen to paper.

—CATHERINE LANGSDORF

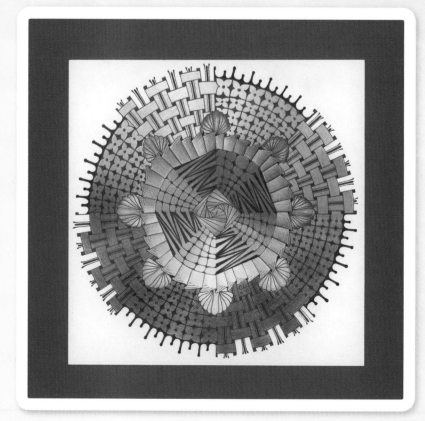

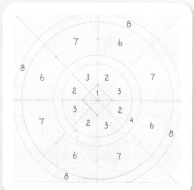
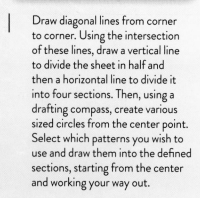
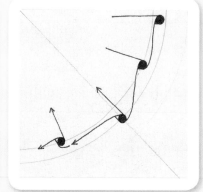
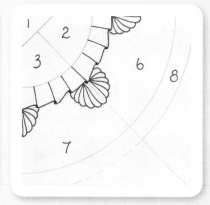

1 | Draw diagonal lines from corner to corner. Using the intersection of these lines, draw a vertical line to divide the sheet in half and then a horizontal line to divide it into four sections. Then, using a drafting compass, create various sized circles from the center point. Select which patterns you wish to use and draw them into the defined sections, starting from the center and working your way out.

2 | Create a ruffle pattern around the complete inner circle. This pattern begins with evenly spaced solid dots. Next, connect each dot to the next one with an S-shaped line. Then draw a line from the left side of each dot toward the center of the mandala, stopping where it touches the line of another pattern. Add a very tiny fill-in on the right side of each dot.

3 | Create a scallop shell design on each spoke. This doodle is made with the center shape first and then working outward on each side with a curved line. Continue filling in the remaining sections of your color wheel with patterns. The final step is to add the color. I used colored pencils, but you could use any medium you enjoy.

Sign up for our inspiring and free newsletter at CreateMixedMedia.com.

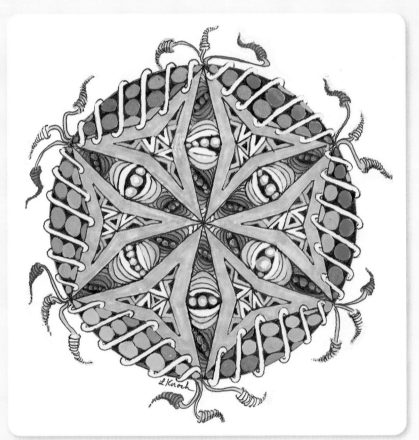

peas in a pod
DR. LYNNITA K. KNOCH

4⅝" (12cm) diameter
Sakura Pigma micron 01 and 05 black pens, graphite pencil, Soufflé pens, Glaze pens, Prismacolor markers, metallic markers and Tombow markers on 2-ply vellum bristol tile

I don't do many zendalas (circular Zentangles) or add color to my Zentangles. I wanted to do both with *Peas in a Pod.*

creative minds are rarely tidy, so embrace imperfections.
—DR. LYNNITA K. KNOCH

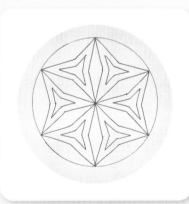

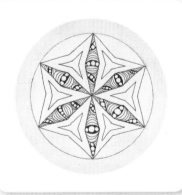

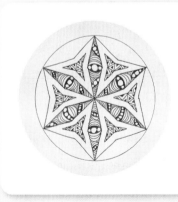

1 Create a circle, leaving at least a ½" (1cm) margin. Divide the circle into sixths with elongated diamond spokes. Around the perimeter, create more diamond shapes between each spoke. Within the six-sided shape created by these diamonds, echo a smaller shape.

2 Fill the diamond spokes with the Inapod tangle (circles with crescents along two sides).

3 Fill the six-sided smaller shape with triangles. Add other patterns, colors and shades as desired.

whirled peace
CATHERINE LANGSDORF

8½" × 8½" (22cm × 22cm)
Sakura Pigma micron pens 01 and 005, water-soluble oil pastels, chalks, silver Wink of Stella pen, white gel pen and soft pencil on bristol paper

I was introduced to the Pinwheels for Peace project, celebrated every September 21. I was captivated by this global peace initiative and wanted to put my spin on it. The doodle began with the pinwheel as the center for the design. Because wind is an essential element to give motion to a pinwheel, I created doodles to convey wind. My primary art form is calligraphy, so it was instinctual to add words into the wind.

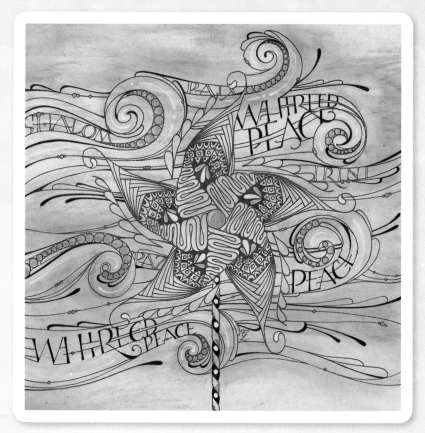

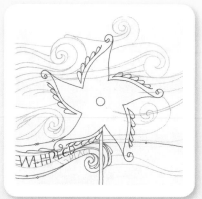

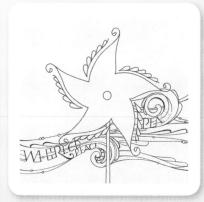

1 Start with the outline of the focal image. To create the background, create some gently curving lines and spirals. I find that I can create smoother lines by working from top to bottom, so I rotate the tile 90° to draw vertical lines.

2 Pencil in various words among the waves and swirls. Ink in the letters with the 005 micron to build up the letter forms. Interrupt some lines with small circles. Be sure that the lines flow from side to side. Parts will disappear under a swirl or the image, but continue to doodle until you reach the opposite side.

3 Build up the background by adding double lines, circles and slugs using the 01 micron. Make circular shapes and swirls like the C shape. Balance the image by thickening some lines and curves with the 005 micron. Erase any leftover pencil lines.

Sign up for our inspiring and free newsletter at CreateMixedMedia.com.

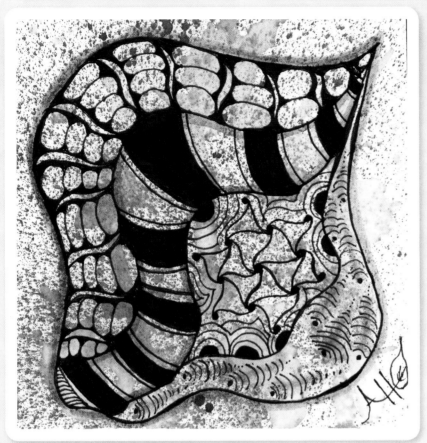

seashell

ALICE HENDON, CZT

3½" × 3½" (9cm × 9cm)
Adirondack Color Wash ink sprays from Ranger, Sakura Pigma micron 01 pen and graphite on 100% cotton, heavy-weight fine artist's paper with a vellum surface finish

Though tangling calls my name, colorful sprays and inks call it even louder. Finding the lines of the color, the way it flows and ebbs on your paper, and deciding which tangles to use will bring it to life. It's like putting together a wonderful jigsaw puzzle without the picture on the front of the box.

Art is a collaboration between God and the artist, and the less the artist does, the better.

—ANDRÉ GIDE

1 In pencil, lightly draw boundary lines to use as guides for filling in tangles, flowing with the color if appropriate. Don't worry— your pencil line will fade gently into the background.

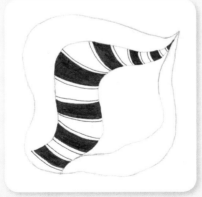

2 Start by drawing broad bands with a thin line on either side, then darken those bands with a micron pen.

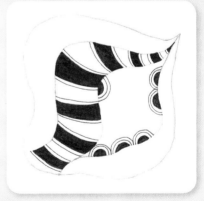

3 Draw half-moon shapes around a border, fill them with color and outline them twice.

safe passage
CATHY CUSSON

3½" × 3½" (9cm × 9cm)
Sakura Pigma micron pens 01 and 08,
graphite pencil on heavy card stock

Inspiration for strings can be found
in many places: cracks in sidewalks,
peeling paint on old wood or perhaps
the sunlight and shadows on the
art room floor. Always keep your
eyes open for interesting designs in
unusual places.

*Find a quiet moment
each day to renew
your sense of wonder.*
—CATHY CUSSON

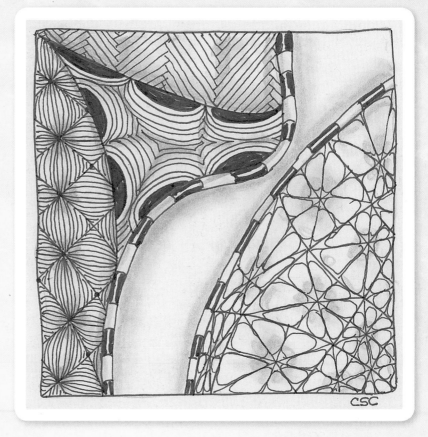

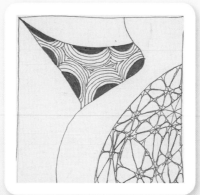

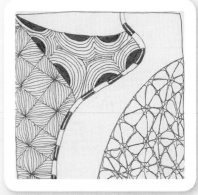

1 Create an outside border on the
tile. Borrow some designs made
by cracks on a concrete porch
and draw a string.

2 Use your pen to outline the
shapes, changing and defining
areas as they appeal to you.
Begin filling areas with your
favorite tangles.

3 I used the snake doodle to
help define the white space I
wanted to have on my tile. It
is important to remember that
leaving white space, or negative
space, adds drama to your piece.

Sign up for our inspiring and free newsletter at CreateMixedMedia.com.

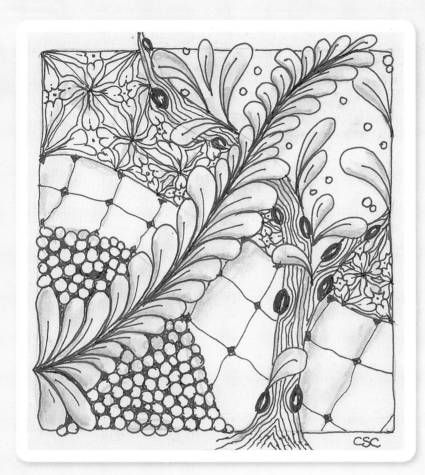

THE TREE
CATHY CUSSON

3½" × 3½" (9cm × 9cm)
Sakura Pigma micron pens 01 and 05, graphite pencil on heavy card stock

Sometimes when I tangle, I have to be prepared to let my pen take me in directions I had not originally planned to go. In this piece, I was planning to fill the spaces with some of my favorite grid-type tangles, but my pen had some other ideas.

Every great dream begins with a dreamer. Always remember, you have within you the strength, the patience and the passion to reach for the stars to change the world.
—HARRIET TUBMAN

1 Lightly pencil in your border, then make several curvy lines from one side of the tile to the opposite.

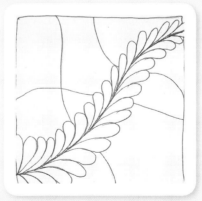

2 Choose one line to be your focal point and create a tangle along that line. Here I used Flux to be my focus.

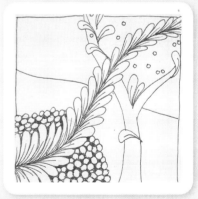

3 After working on my focal point, I saw a tree shape that I hadn't noticed before. I used a pencil to lightly define the tree. Add more organic tangles and remember that your string is just a guide—not something to which you must adhere.

grandma's quilt
CATHY CUSSON

3½" × 3½" (9cm × 9cm)
*Sakura Pigma micron pens 01 and 08,
graphite pencil, Sharpie marker on
heavy card stock*

Most of the time I prefer my string
to fade into the artwork. However,
when a string is obvious, why not
make it really stand out? A small
amount of color on the string can
make your design pop.

*you've always had
the power, my dear.
you just had to learn it
for yourself.*

—GLINDA, *WIZARD OF OZ*

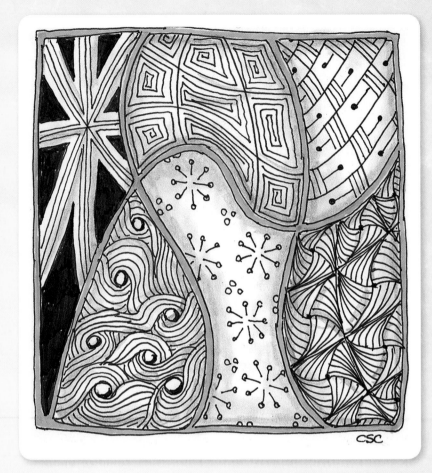

1 Divide your tile into several
uneven shapes, moving from
one side to the other.

2 Outline the string and then draw
a parallel line alongside the string.

3 Fill your areas with a different
tangle in each one. Use a
colored marker or pencil and fill
in your string.

Sign up for our inspiring and free newsletter at CreateMixedMedia.com.

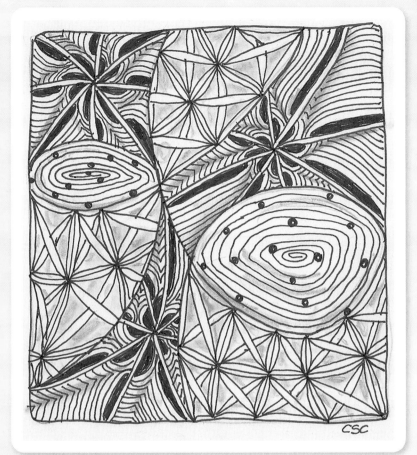

cactus drums
CATHY CUSSON

3½" × 3½" (9cm × 9cm)
Sakura Pigma micron pens 01 and 05, graphite pencil, Sharpie marker on heavy card stock

Often I really don't have a plan when I doodle. I just try to relax by filling in the shapes on paper as I empty the spaces in my mind. It calms me and helps me give more focus to projects and other things that need my attention.

creating things and working with my hands is as necessary as air!

—CATHY CUSSON

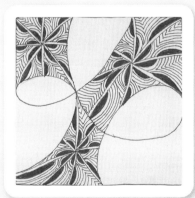

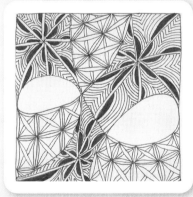

1 After drawing the border, make one continuous string, looping and swirling around the tile.

2 Use the Ixorus design to fill three of the large shapes. The dark spaces in Ixorus complement the round shapes on the overall tile. Choose tangles that accent your string shape.

3 Follow the curves of your shape and let the boxes of the grid change size as you work across the area. Rather than leaving the loops white, fill the circles with shapes that remind you of the top of a drum.

All curves and color
EDEN M. HUNT

3¾" × 3¾" (10cm × 10cm)
Micron pen and colored pencils on drawing paper

This wonderful wavy pattern is called "Kunstler" and was introduced by Julianna Kunstler. The lines are simple and repetitive and can be very relaxing and somewhat meditative to do. Julianna used strong colors in her example, but this pattern also does wonderfully in black and white with deep shading along the long lines. It works great if you're going for a three-dimensional look and is well suited to all sorts of spaces, as well as standing alone in a monotangle like this one.

Learning in the traditional sense does not really apply to art.
—EDEN M. HUNT

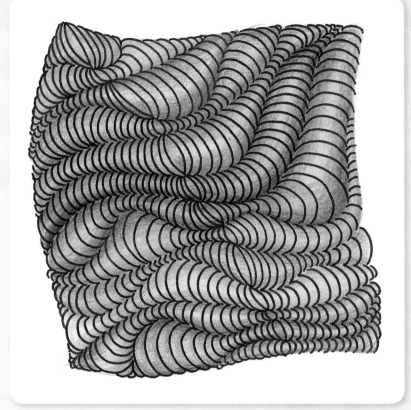

1 To begin this pattern, draw a series of wavy lines, mostly in the same direction, varying the space and curve between the lines. Then draw a single curve across all the lines.

2 Begin to fill in the curvy columns with half-moons curved downward above the curve and upward below the curve. Vary the amount of curvature and the spacing of these half-moon shapes.

3 Completely fill in the central space formed around the crosswise curve by the first two half-moon shapes, or add black circles. Then add pencil shading along the edges of the columns.

Sign up for our inspiring and free newsletter at CreateMixedMedia.com.

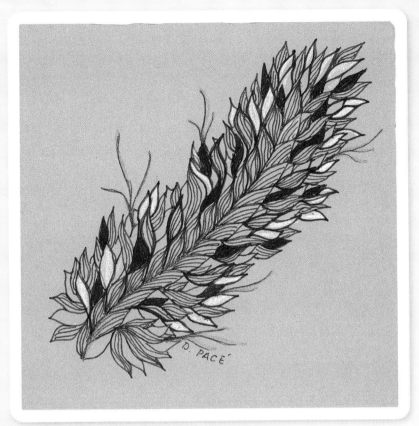

feathers
DEBORAH A. PACÉ

3¾" × 3¾" (10cm × 10cm)
Sakura Pigma blue micron pen 01, Sakura Pigma white and Clear Stardust gelly roll pens on Zentangle tan tile

Here I was playing with a pattern but not really liking it. So I ended up repeating the design and played with it until everything came together. I find that sometimes we stop at ugly, premature stages—not letting ourselves go beyond what we see until we get to amazing.

we need not be afraid to experiment and see what if…

—DEBORAH A. PACÉ

1 Start by making leaves in a V shape, coming out of the center and continuing upward.

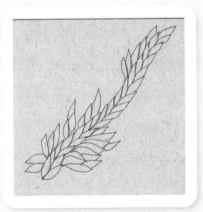

2 Add more leaf shapes along each side.

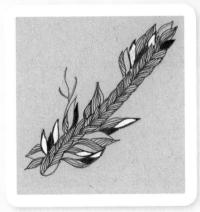

3 Add lines to the leaves, color some in, add white to others and then add a bit of sparkle.

moon flowers
DEBORAH A. PACÉ

2" × 8¼" (5cm × 21cm)
Speedball paints, Sakura Pigma black micron pen 01 on Stonehenge printmaking paper

I took a printmaking class and had done some prints, but I wasn't too happy about the way they turned out. I ended up cutting the paper to use as a cover for a journal. In the end, I liked the way it looked and decided to use it as a bookmark but wanted to add more to the design. So I started reworking it and let the design of the paint guide me. Before I knew it, I started doodling here and there and voila!

sometimes imperfection is by far better than perfection.

—DEBORAH A. PACÉ

1 Start with any type of paper that will accept paint. You can use acrylics, watercolor or any kind of paint you have on hand. Experiment. Wet the paper and let the colors flow.

2 After the paint has dried, let the design of the colors speak to you and start doodling on the paper.

3 Continue drawing, letting the design of the paint speak to you until you are satisfied with the design.

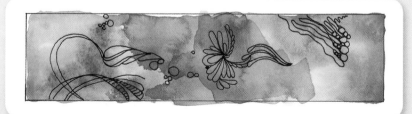

Sign up for our inspiring and free newsletter at CreateMixedMedia.com.

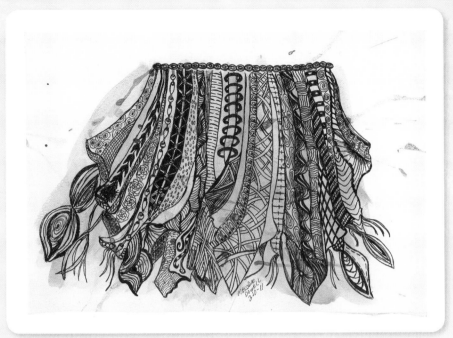

gypsy skirt
MELODIE DOWELL

7½" × 11" (19cm × 28cm)
*Micron pens, pencil and water-color on 140-lb. (300gsm)
Arches watercolor paper*

This was inspired by my love of drawing fabrics and dancers and flowing clothing. I put the watercolor on the paper and let it dry. Afterward, I used pens to draw over it. This was a work that just developed as I went. I didn't know it was going to come out looking like fabric, but I did know it was going to end up looking like a flowing skirt—it reminded me of Gypsies.

1 Draw the pods. They come in all shapes and sizes.

2 Fill the pods with anything you dream up. Even peas!

3 Remember to use a pencil for shading. It will add depth and interest to your drawing. The small curved line on the pea gives it the look of a circle or something round.

bridgen again
EDEN M. HUNT

3" × 2¾" (9cm × 7cm)
Micron pen on drawing paper

One of the reasons I doodle is to relax and not consciously think about the other things going on in my life. As a result, I often default to patterns that are comfortable for me and that I can do without too much thought. However, occasionally I like to challenge myself to try a pattern that did not work out well the first time I used it and might require a little more thought and planning. In this case, it was Bridgen, which has very little structure of its own and can get a bit chaotic very quickly.

you can't use up creativity. The more you use, the more you have.

—MAYA ANGELOU

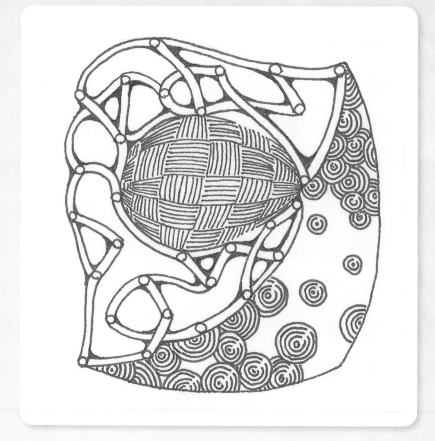

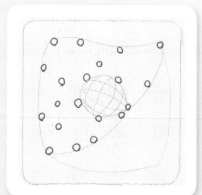

1 | Begin by drawing a curvy square shape, trying to not worry too much about straight lines and square corners. Starting in one corner, add a curvy loop through the middle of the square, ending in the opposite corner, making a teardrop shape.

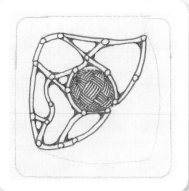

2 | With a pencil, give yourself a very light contoured grid in the teardrop and use a nice, regular grid pattern to fill it. With some shading and this contoured grid, this shape will really take on a three-dimensional feel.

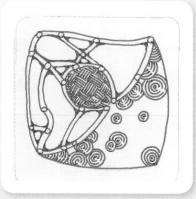

3 | Draw in some small circles that will act as hubs for the bridges. Connect the hubs with the bars that form the bridges and fill the angles at the intersections a bit.

Sign up for our inspiring and free newsletter at CreateMixedMedia.com.

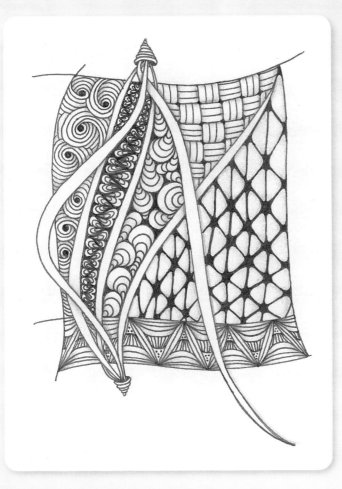

QUIB QUIP
EDEN M. HUNT

4" × 6" (10cm × 15cm)
Micron pen on drawing paper

Contrary to some suggested practices when doodling, I always give myself a very light pencil grid to work with for the more regular patterns. If I try to be more freewheeling and let the pattern emerge on its own, it will often become lopsided or uneven. I can appreciate and even admire those kinds of looks in others' work, but they make me crazy in my own. That angst makes the relaxation I am looking for when I draw elusive. I think the lesson is to simply do what works for you.

visit createmixedmedia.com/zen-doodle-oodles-of-doodles *for some bonus step-by-steps from this artist!*

if you're not prepared to be wrong, you'll never come up with anything original.
—SCOTT ADAMS

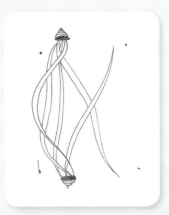

| | This piece was an excuse to try the Quib pattern, so I let its wandering lines define the areas to be filled and drew the layered tendrils first.

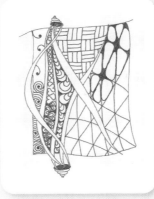

2 After defining the drawing space behind the Quib, I selected patterns to fill the spaces with an eye toward balancing the patterns by choosing some free-flowing curvy patterns and some more regimented grid-based designs.

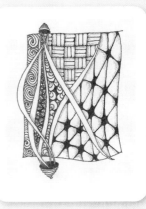

3 The final touch is always shading to give all the patterns some dimension. The focus elements can be made to rise up off the page with the addition of a consistent shadow following the contours across all other pattern spaces.

Leaf
DEBORAH A. PACÉ

4¼" × 5¾" (11cm × 15cm)
Sakura Pigma black micron pen .01, Sakura Pigma gold gelly roll pen on Strathmore toned gray paper

Being playful sometimes brings out the creativity in me. One of the things I like to do when I can't get started is go to my favorite go-to pattern, which is usually a leaf of some sort. Here, the leaf was too plain for me, so I added a few twigs and a playful stem.

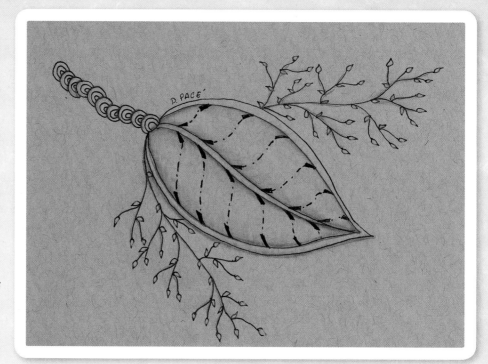

motivation gets you going, and habit gets you there.
—ZIG ZIGLAR

1 Draw a leaf shape.

2 Draw another line around your leaf shape and two lines down the center.

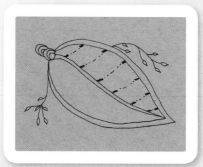

3 Embellish your leaf, add some twigs and a playful stem, and shade.

Sign up for our inspiring and free newsletter at CreateMixedMedia.com.

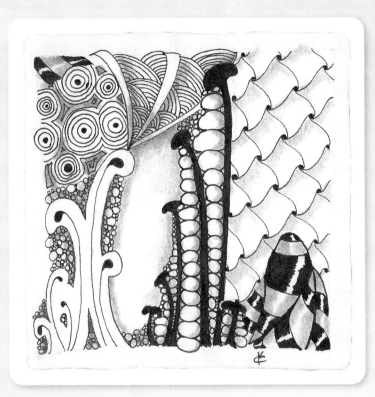

saturday, february 22
KATIE CROMMETT

3½" × 3½" (9cm × 9cm)
Sakura Pigma micron 01 and 03 pens and pencil on official Zentangle tile—Fabriano Tiepolo, 100% cotton heavy-weight fine artist's paper

As a kid, I loved doodling. My brother and I used to spend hours co-drawing imaginative creatures and fake video game instruction manuals. My dad used to draw squiggles for us on restaurant paper placemats to keep us amused. Now, as an adult, I still need an outlet for fun, creative play. Zentangle satisfies that need for me. This tile was created in response to an "I Am the Diva" weekly Zentangle challenge (iamthedivaczt.blogspot.com), which asked participants to include white space in the tile.

our deepest fear is not that we are inadequate. our deepest fear is that we are powerful beyond measure. it is our light, not our darkness, that most frightens us. we ask ourselves, who am i to be brilliant, gorgeous, talented, fabulous? Actually, who are you not to be?
—MARIANNE WILLIAMSON

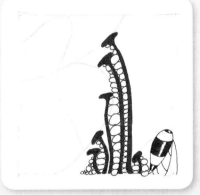

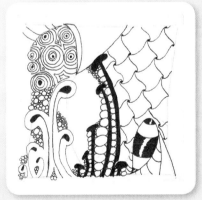

1 Using a pencil, draw one dot in each corner of the piece of paper. Then connect the dots with lines to create a boundary for your drawing. Next, draw your string (or, what my dad calls it, the "squiggle").

2 Fill in each segment with a pattern (or tangle) using a fine-point black pen. Take your time and focus on the enjoyment of feeling the pen move along the paper.

3 To create dimension and interest, shade the shapes you've drawn. But most of all, enjoy the journey regardless of the outcome!

leaf

HEATHER M. JACKSON

3½" × 3½" (9cm × 9cm)
*Sakura Pigma black ink micron pens
01 and 005 on Strathmore artist
tiles, 100-lb. (215gsm) bristol with
vellum surface*

In 2013 I joined the Doodle Swap
Project (doodle-swap.com) and began
doodling and tangling miniature
pieces of art for trading. Inspired
by the structural formations of leaf
patterns in nature, I experimented
with my two favorite tangles:
Maria Thomas's Fengle and Norma
Burnell's Dragonair. I had fun
creating variations of these two
tangles by varying the sizes of their
basic backward S-shaped stroke. For
shading, I used the stippling technique
inside the leaf shapes and filled the
background with a circular pattern
that contours the spiraling swirls.

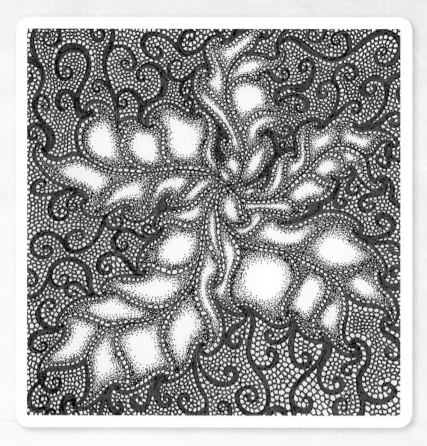

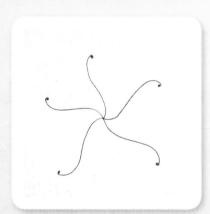

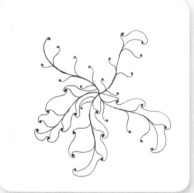

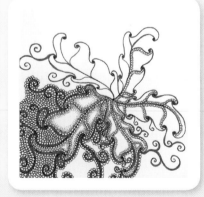

1 Starting from a center point,
draw about five S-shaped lines,
spiraling outward with tiny dots
at the ends. Turn the tile as you
go around.

2 From the center, draw smaller
backward S-shaped lines in an
upward fashion, adding a tiny dot
at the ends. Repeat this pattern.
Then, working from the ends to
the center of each of the five initial
lines, connect the dots with more
backward S-shaped lines, curving
around to the inside part of the dots.

3 Embellish the leaf veins with small
circles following their structures.
Draw swirls randomly spiraling out
from the dotted ends of the leaf
veins. Fill in the outside areas with
small circles, patterning around the
swirls and outlining the leaf shapes
for contrast. Shade as you like.

Sign up for our inspiring and free newsletter at CreateMixedMedia.com.

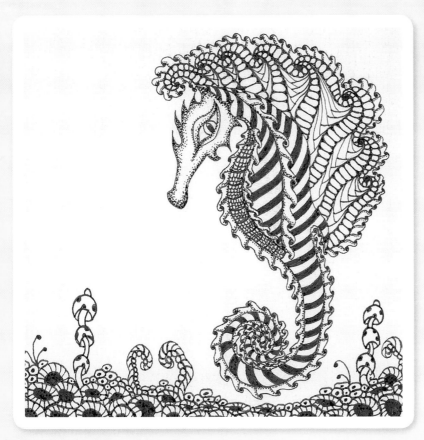

seahorse
HEATHER M. JACKSON

3½" × 3½" (9cm × 9cm)
*Sakura Pigma black ink micron pens
01 and 005 on Strathmore artist
tiles, 100-lb. (215gsm) bristol with
vellum surface*

Ever since I can remember, my favorite place to be is the beach. I especially delight in collecting a bucketful of seashells while walking on the shore. Inspired and influenced by CZT Penny Raile's ocean creatures and my love for the beach, I created my sea horse Zen Doodle.

journaling is a dream catcher for the creative spirit and helps me process what steps I need to take to fulfill my aspirations in life.
—HEATHER M. JACKSON

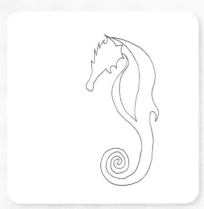

1 Lightly pencil or trace a simplified sea horse shape and ink it.

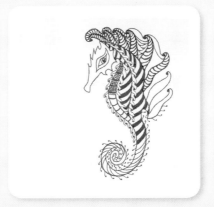

2 Section off areas for features such as eyes, spiny horns, chest ridges, fins and a spiraling tail. Within these areas, draw your favorite patterns. I striped the body and tail, and for a spiny ridge effect, I used CZT Norma Burnell's Dragonair.

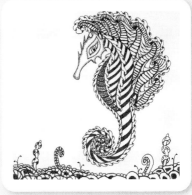

3 Add an ocean floor with whatever sea creatures and plants you can imagine. I based mine on Penny Raile's Fish Aquarium. Shade as you like. I prefer a stippling technique for more contrast.

providence Floral

JANE REITER

3½" × 3½" (9cm × 9cm)
Black Sakura Pigma micron pen on white Zentangle tile

I created this tangle pattern while at the Certified Zentangle Teacher training seminar in Providence, Rhode Island. I was inspired by a pot of flowers lining one of the downtown streets.

Finding zentangle has changed my life for the better since training as a CZT in 2012. I believe tangling has loads of benefits for others too!

—JANE REITER

1 Draw diagonal lines at a slight angle across the tile vertically, moving left to right.

2 Draw diagonal lines at a slight angle across the tile, moving in the opposite direction. These lines create a diamond grid of intersecting lines.

3 Draw a curving stem and four-petal bloom in each diamond, filling the entire grid. Then complete each flower with two small curving lines that form stems for buds.

Sign up for our inspiring and free newsletter at CreateMixedMedia.com.

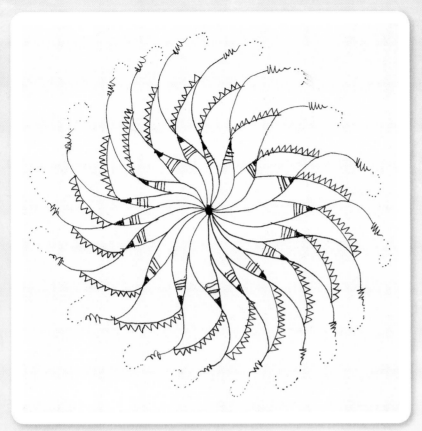

Arrow Fengle
JANE REITER

5½" × 5¼" (14cm × 13cm)
Black Sakura Pigma micron pen on Strathmore sketch pad paper

Fengle is one of my favorite tangles to draw because it offers much room for personal interpretation. The flourishes remind me of painted arrows, hence the title.

Let yourself be silently drawn by the strange pull of what you really love. It will not lead you astray.
—RUMI

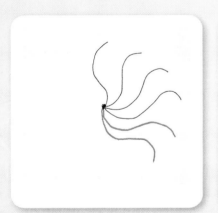

1 | Put a dot in the tile's center as your reference point. Draw S curves, working from the outside edge and connecting to the center dot, moving around the whole spiral.

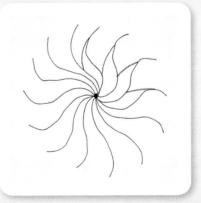

2 | Connect each S line to its neighbor, using a gently curving line.

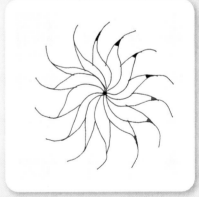

3 | Accentuate the tip of each S with a blackened triangle. Add four delicate aura lines beneath each solid triangle. Further enhance each S line.

Birdie
JAY WORLING

4" × 5" (10cm × 13cm)
Pen, pencil on paper

I have been very interested in the recent burst of popularity in bird forms. They have been appearing on everything from book covers to folk art. So I thought I would try creating a Zen Doodle-style bird of my own.

miracles start to happen when you give as much energy to your dreams as you do to your fears.
—UNKNOWN

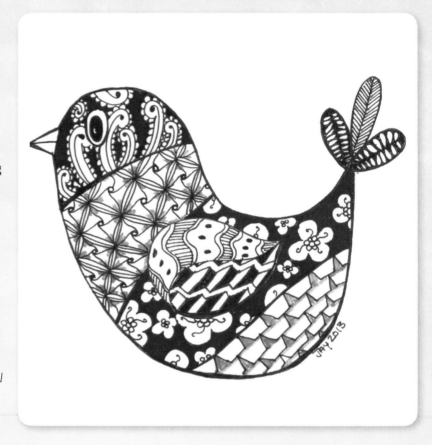

1 In the center of your page or tile, draw a jelly bean shape that is pinched at one end.

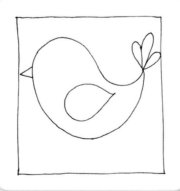

2 Add a triangle (beak) at the front, then add a wing and three tail feathers.

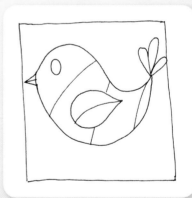

3 Draw in the eye and divide your bird shape into sections. You are now ready to add any doodle patterns you like to each section.

Sign up for our inspiring and free newsletter at CreateMixedMedia.com.

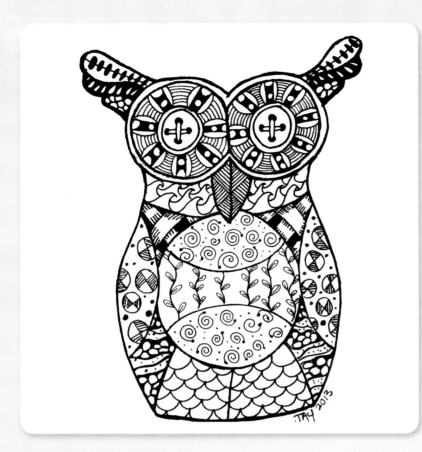

owl
JAY WORLING

6" × 4½" (15cm × 11cm)
Pen on paper

I have a real love of animals and birds, and I particularly like owls. To me, they are symbols of wisdom and far-seeing. This is my tribute to these wonderful, feathered creatures.

If you are going to laugh about your mistakes and failures in ten years' time, you may as well laugh at them now.

—JAY WORLING

1 Draw a series of wiggly lines in one section of your owl. These form the stalks of the hedge.

2 Add leaf shapes all the way down each stalk. You can make them at regular intervals or randomly.

3 In the center of the leaf shapes, draw a short line to represent the main vein in a leaf.

tree
JAY WORLING

5½" × 5" (14cm × 13cm)
Pen on paper

Trees and natural forms lend
themselves perfectly to Zen
Doodling because as you look at
them, they are easily drawn and
then divided into sections for filling
with your chosen patterns. When
filling this tree form with patterns,
I chose to use alternating bold and
delicate doodle designs to create a
balance. The other thing about using
nature as inspiration is there are very
few straight lines in nature, so the
perfection is in the imperfection!

*Even the longest
journey must begin
where you stand.*
—LAO TZU

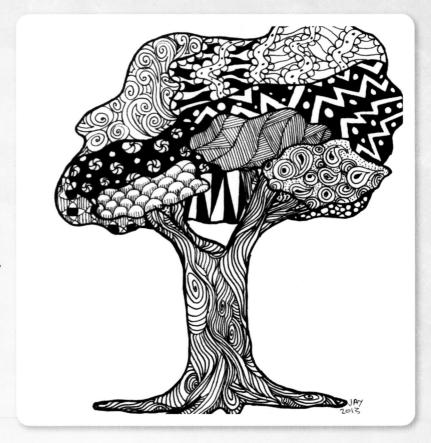

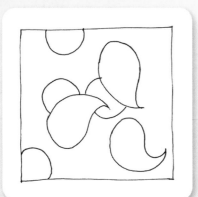

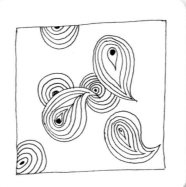

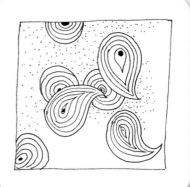

1 Draw a few paisley shapes and
 intersect them with some circles.

2 Inside each paisley and circle,
 draw more lines of the same
 shape to fill the space. You can
 decide if you want the lines
 a uniform distance or more
 random. Draw a dot in the
 center of the inner lines.

3 Randomly create dots in the
 background space.

Sign up for our inspiring and free newsletter at CreateMixedMedia.com.

symphony on grey
PAT TRACZ

Sakura Pigma black micron pens 005, 05 and General white chalk pencil on Strathmore recycled toned sketch journal

I was inspired to try tangling on toned paper after a meeting with the Philly Area Zentangle group where I saw another member's work on tinted paper. I liked the idea of using a white pen/pencil for highlights, which gives a little bit more dimension than just shading.

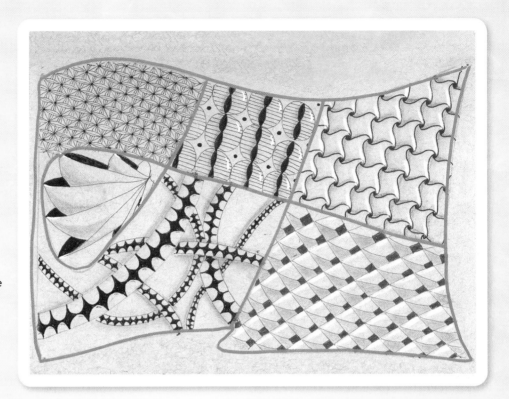

1 After connecting the dots in all four corners, create a flowing string to divide the space. I like to include swirls.

2 Choose the pattern Cadent for the first area and fill it in.

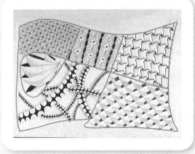

3 Continue filling the areas with patterns that lend themselves to the area. I like to use a combination of symmetrical, grid patterns (Cadent, Cubine and Versa) with some more organic, flowing patterns (Phicops, Snaking and Rondelles).

rosetangle: 3 blooms and purk

JULIA OLSEN

4" × 4" (10cm × 10cm)
Sakura Pigma micron black 01 and 03, and charcoal pencil soft on smooth white 80-lb. (170gsm) card stock

I discovered Zentangle just a few months ago and was instantly hooked! Soon I had a pile of tiles to show for it and, through the repetition of pen strokes, I noticed some were similar to the brushstrokes I learned about when I tried my hand at *rosemaling*. That's a Norwegian word that means *flower painting* and refers to a four-hundred-year-old decorative painting style that creates fanciful flowers, leaves and sometimes insects. While the differences between the two are obvious, I was intrigued by the crossover elements. So I played around with combining them.

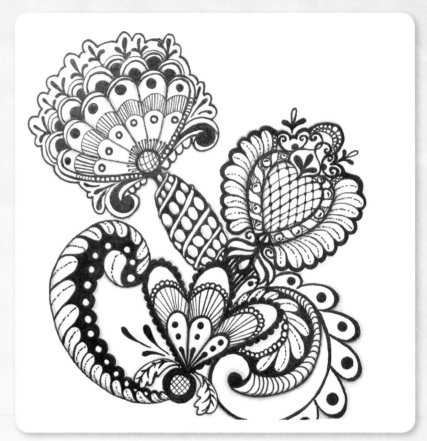

Fear is merely an expression of your desire for its opposite.
—JULIA OLSEN

1 Draw three circles (shown in black). Add simple shapes to form blooms as shown here in red. The heart is easy to recognize; the top left fan-type form is a series of cones drawn next to each other. The bottom bloom is three teardrops drawn upside down.

2 Create leaves and embellish with other doodles.

3 Add scrolls and scallops for leaves. Keep adding designs and don't worry about how it will turn out.

Sign up for our inspiring and free newsletter at CreateMixedMedia.com.

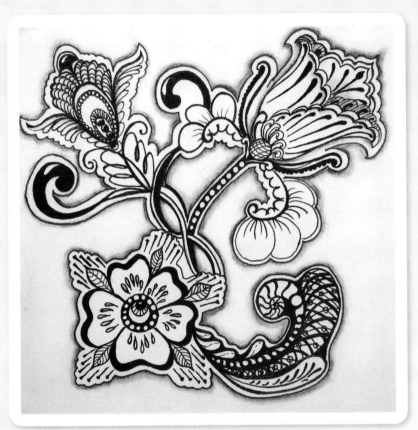

ROSETANGLE: 2lip +2
JULIA OLSEN

4" × 4" (10cm × 10cm)
Sakura Pigma micron black 01 and 03, and charcoal pencil soft on smooth white 80-lb. (170gsm) card stock

This tulip is a common form in rosemaling, as is the daisylike flower (bottom). The fantasy bloom (top left) is one I made up, which is also commonly done. Both art forms use scroll, crescent, spiral or coil, teardrop and comma shapes, and cross-hatching. I get inspired looking at the beautiful pictures on the Internet or in my old technique books.

Be yourself. Nobody is better qualified.
—JULIA OLSEN

visit createmixedmedia.com/zen-doodle-oodles-of-doodles for some bonus step-by-steps from this artist!

1 Draw three circles and add simple shapes to form blooms.

2 Add scrolls and scallops for leaves and stems.

3 Keep adding strokes, Zentangle designs or shading.

Queen's Bloom

JULIA OLSEN

4" × 4" (10cm × 10cm)
Charcoal pencil soft and Sakura Pigma micron black 01 and 03 on smooth white 80-lb. (170gsm) card stock

I find this art form appealing due to growing up in the '60s and '70s—the age of psychedelic flower power. Also, I am part Norwegian. I got started as an artist later in life after getting injured, sick and disabled. An irresistible urge to paint seemed to come out of the blue, as I had never painted anything but walls before. I think the original rosemaling artists of four-hundred years ago must have been some pretty hip Norwegians in their time!

it's never too late to be what you might have been.

—**GEORGE ELIOT**

1 Draw a few paisley shapes and intersect them with some circles and swirls.

2 Inside each paisley and circle, draw more lines of the same shape so they fill the space. You can decide if you want the lines a uniform distance apart or more random.

3 Randomly add dots to the swirls and embellish the bloom with other shapes, patterns and designs.

Sign up for our inspiring and free newsletter at CreateMixedMedia.com.

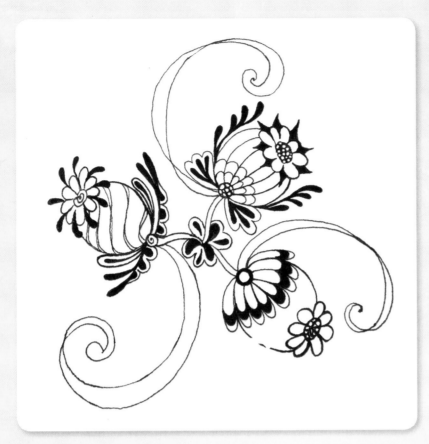

3 A-TWIRL
JULIA OLSEN

4" × 4" (10cm × 10cm)
Charcoal pencil soft and Sakura Pigma micron black 01 and 03 on smooth white 80-lb. (170gsm) card stock

I always start with one to three circles, following my impulses for placement and sizes—large or small. This is similar to the way Zentangles start with a string. Then I build onto the circles to create a basic flower form. Next I add stems and leaf forms, and add onto it from there. Follow your creative impulses; there is no right or wrong in art or meditation.

The more we allow ourselves to unfold, the less likely we are to unravel.

—RABBI IRWIN KALA

1 Draw three circles and add simple shapes to connect them to one another.

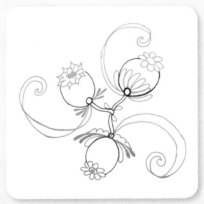

2 Add simple flourishes, leaves and stems.

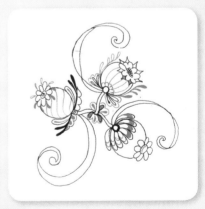

3 Keep adding strokes, Zentangle designs or shading.

windows of summer

LISA CHIN

3" × 3" (9cm × 9cm)
*140-lb. (300gsm) vellum finish
mixed-media paper and Pigma
Sakura micron pens*

In the middle of a raging winter,
summer always seems so far away.
I like to comfort myself by drawing
flowers. The curve of the petals
relaxes me and reminds me that
warm days are ahead.

*stop worrying and just
do it!*

—LISA CHIN

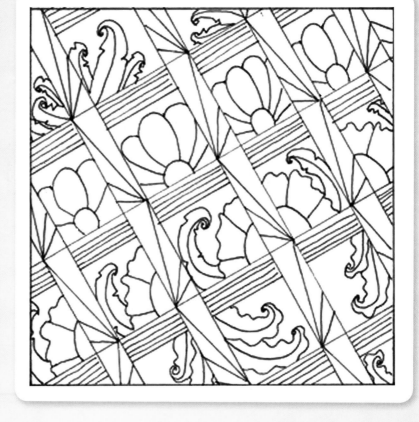

1 Begin this doodle by creating
windows for the flowers to peek
through. Draw the first line at a
60° angle from the corner. Note
that the shades on the windows do
not go all the way across the page.
Add lines to each window shade.

2 Decorate the sashing of each
window with angled lines in
opposite directions.

3 Fill each window with just a glimpse
of a summer flower or leaf.

Sign up for our inspiring and free newsletter at CreateMixedMedia.com.

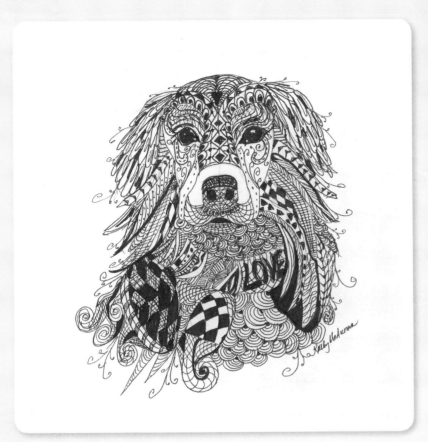

Last chance
KATHLEEN MCARTHUR

9" × 11" (23cm × 28cm)
Pen and ink on bristol vellum paper

Remember that anyone can do this type of art. Look in a magazine for others' patterns and turn them into yours. Just don't stress over perfection; remember, your work is yours and yours alone, and you can make it look any way you want it to. Also, there are no mistakes; you can incorporate anything into your drawings. Just have fun with your work.

zen Doodle has such a calming effect on your soul.

—KATHLEEN MCARTHUR

1	Roughly sketch the outline with pencil first. Be very loose with the initial drawing since long fur goes in many directions.

2	Loosely define the features of the face: the eyes, nose and ears. Use an artist pen F to outline the head, nose and eyes. Crosshatch the nose, loosely for light areas and heavier for darker areas.

3	Fill in the darker heavy areas with a B pen. Draw long feather shapes and use small angled fine lines. Remember to leave some areas white or solid black. When finished, erase any visible pencil marks.

looking for sun
KIM PAY

4" × 4" (10cm × 10cm)
*Sakura Pigma micron 01 on Bee
Paper Company artist marker pad*

I've been doodling since I was a
child. About six years ago, an artist
friend suggested I use my doodles
in my artwork, and now doodles are
the focus of my creativity. I like to
use my original designs or copies of
them in my mixed-media art proj-
ects using lots of different mediums.

*No matter how many
mistakes you make
or how slow you
progress, you are still
way ahead of those
who do not try.*

—UNKNOWN

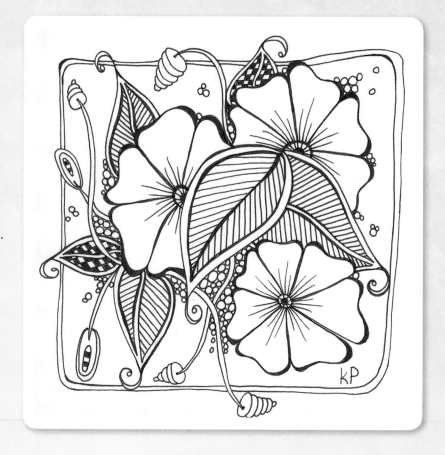

1 Doodle two or three elements
(flowers, leaves, circles, etc.)
that do not touch each other
anywhere on the tile.

2 Add doodle flowers and leaves
around the first elements. Try
to create an overlapping effect
of the flowers and leaves. Add
some tendrils or curvy lines
that appear to sprout from the
doodle. Remember to leave space
between some of the elements.

3 Thicken some lines by going over
them with your pen to create a
shading effect. This will add some
dimension to the doodle. Fill in
spaces with repeating patterns.
I like to doodle little circles in
clusters and have a few of them
loosely floating around. A border
makes a nice finishing touch.

Sign up for our inspiring and free newsletter at CreateMixedMedia.com.

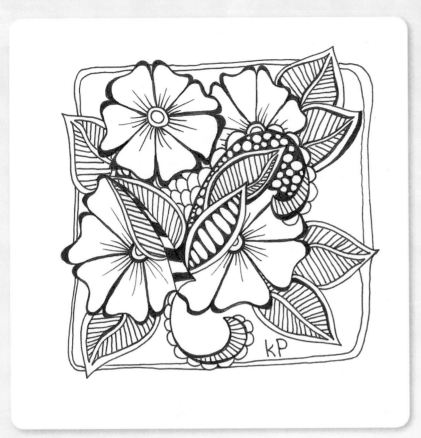

morning blooms
KIM PAY

4" × 4" (10cm × 10cm)
Sakura Pigma micron 01 on Bee Paper Company artist marker pad

I like to work in a series. This allows me to explore all the different ways a pattern or doodle can be used. Instead of shading with a pencil, I like to thicken lines with my pen. Adding different details and sometimes color to a doodle will give it a completely different look from previously doodled tiles.

Follow your heart, believe in your dreams and create.
—UNKNOWN

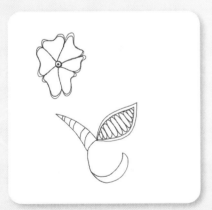

1 Start doodling a flower at the top of the tile and some random shapes below it.

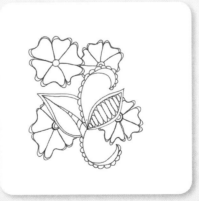

2 To join the flower with the other elements, add details to give the random elements a leaflike quality. Add more flowers around these doodles and make them appear like they are partly underneath.

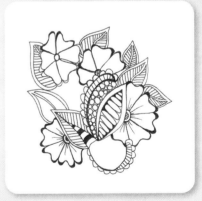

3 Add circle clusters and scallops to fill in the empty spaces and add details to the flowers. Also thicken some lines. Then add a border to finish this doodle off (sometimes I like to leave the doodle floating on the tile).

full bloom

KIM PAY

4" × 4" (10cm × 10cm)
Sakura Pigma micron 01 on Bee Paper Company artist marker pad

Winters in Alberta, Canada, can be long, and I sometimes find myself doodling flowers and wishing for warmer weather. When looking for inspiration, I often find it in the garden, but when snow covers everything, a trip to the mall gives me lots of ideas from the patterns on clothes to the designs on the floor or ceiling.

Nothing will stop you from being creative so effectively as the fear of making a mistake.

—JOHN CLEESE

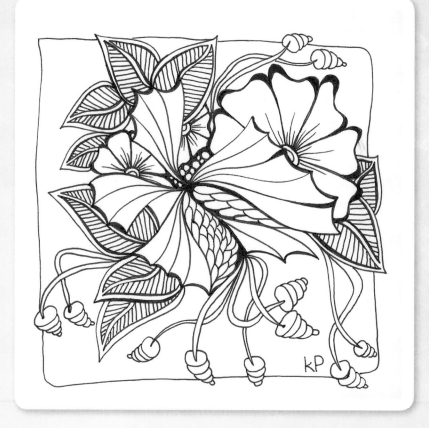

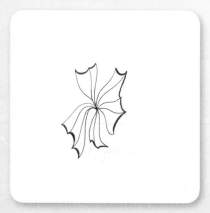

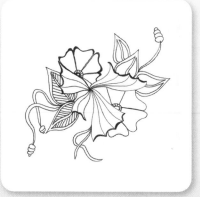

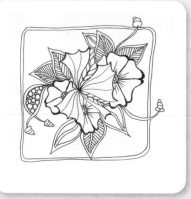

1 | Doodle lines curving out from a center point and then join some of the lines together at the end with a scallop shape. Make the ends thicker and darker by going over them with your pen.

2 | The curvy lines look like petals, so add some flower doodles and leaves. Thicken the lines and add some details as the doodle evolves.

3 | Add more intertwined tendrils (Zingers) and some repeating patterns in the empty spaces. Add a border to help anchor the doodle.

Sign up for our inspiring and free newsletter at CreateMixedMedia.com.

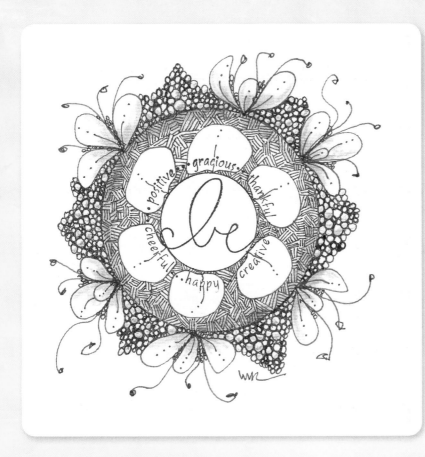

BE
VALENTINE WERCHANOWSKYJ ROCHÉ

4½" × 4½" (11cm × 11cm)
01 micron ink pen on 140-lb. (300gsm) watercolor paper, rubber stamps

I am a mixed-media artist and enjoy adding doodling to my work. Creating art and the doodling process take me into a meditative state, which allows my creativity to flow into my artwork. I love the calm and stillness so I can hear my soul speaking to me. I am inspired by nature.

Art washes away from the soul the dust of everyday life.
—PABLO PICASSO

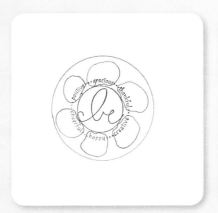

1 Print the *be* stamp into the center of your watercolor paper. Draw a ¾" (2cm) circle around the stamped quote. (Or draw/write a similar design by hand.) Using a modified Flux pattern, draw around the single words.

2 Begin filling the circle with a Nekton pattern.

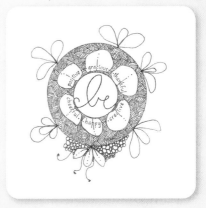

3 Add several Flux pattern leaves on the outside of the circle. Use the Tipple pattern and fill in an irregular shape around the circle. Add the Fescu pattern.

TALL FIR TREES
VICTORIA SCHULTZ GRUNDY

11" × 8½" (28cm × 22cm)
Sakura Pigma micron archival ink pen 01 on card stock

Art has always been healing for me, and this drawing process was very much a tonic. I've always believed anyone can make art because, to me, art is about the doing. I have benefitted firsthand from the meditative zone of being deep into a project. Exploring this art form has been healing and helpful for me as I reinvent my career path and explore the visual arts.

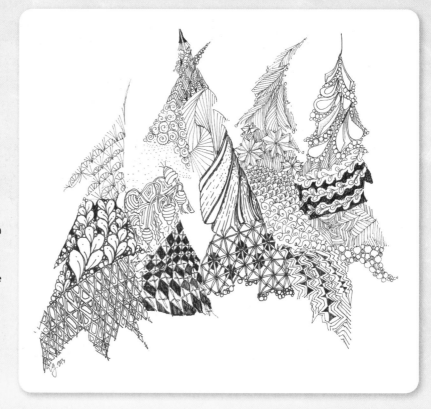

create with joy from your heart and push forward.
—VICTORIA SCHULTZ GRUNDY

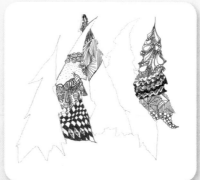

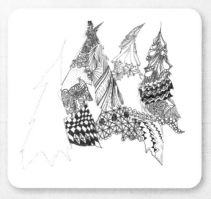

1 Find a shape you like and create a faint outline on your paper with a pencil or light blue colored pencil (which will fade away as you work). This needs to be a really faint line so it doesn't define your edge. You'll want the tangles to do that.

2 Begin filling in your object using tangle patterns you love or want to try. Be aware of the three-dimensional forms your object should have, and try to get the patterns to follow that form if possible. I imagined standing among these beautiful trees with snow falling as I filled in my tangles.

3 Now it's time for the last steps that will make the drawing pop. I darken intersections with the pen and then shade the forms' edges and tangles. You could also add color or metallic inks. Sign, date and admire your work.

 Sign up for our inspiring and free newsletter at CreateMixedMedia.com.

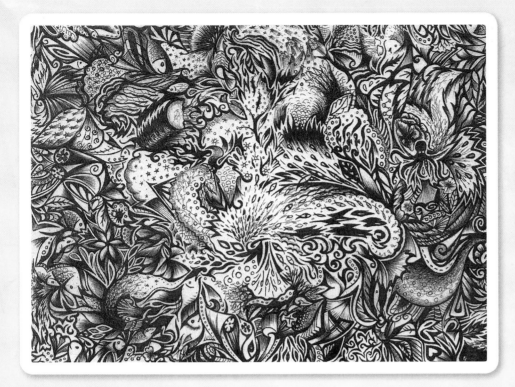

ocean
PATRICIA DAHER

8" × 10" (20cm × 25cm)
Pen on paper

To draw this doodle, I first came up with a theme, ocean, inspired by my constant drawing of fish. I draw whatever thought comes to mind first, and I try to fit the drawings next to each other, like a puzzle.

watch your thoughts and follow your intuition to see where it takes you.
—PATRICIA DAHER

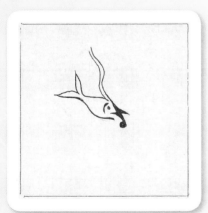

1 Draw a doodle of a fish.

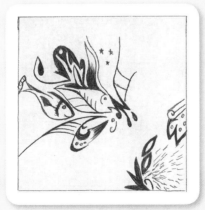

2 Create designs around the fish, embellishing it with lines and waterlike drops. Then branch out and continue tangling and doodling in different areas on the paper away from the original fish.

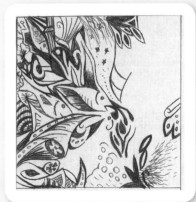

3 Begin filling up the remaining white space of the page using doodles that are not oceanic themed, like stars and flowers.

thanksgiving
VICTORIA SCHULTZ GRUNDY

8½" × 11" (22cm × 28cm)
Sepia Identi-Pen by Sakura Pigma fine tip and extra-fine tip on printed card stock image

I started this work during a Thanksgiving holiday visit with my family. While most of my family watches the football games, my outlet is art. This piece grew out of the wonderful energy from a visit home.

There is no cost to creating positive intentions, and there is a huge return.

—VICTORIA SCHULTZ GRUNDY

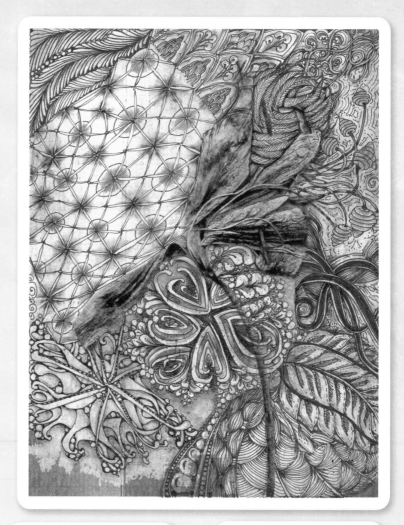

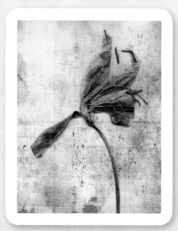

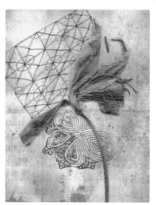

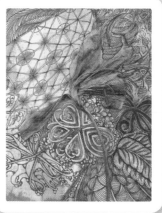

1 Find a photo of a faded item or a background paper that you like. Print it on a thicker paper stock. Be careful not to pick a strong image. It should be subtle so your drawings that go around it will show up.

2 I chose a sepia-colored pen for this piece because I wanted it to look like it blended with the colors already present in the photo. Working on one small area at a time, draw the tangle patterns.

3 Color parts of the design, letting the background color show through. I like to use some coordinating warm tones and then complementary colors to make things pop out. I also use blue to shade.

Sign up for our inspiring and free newsletter at CreateMixedMedia.com.

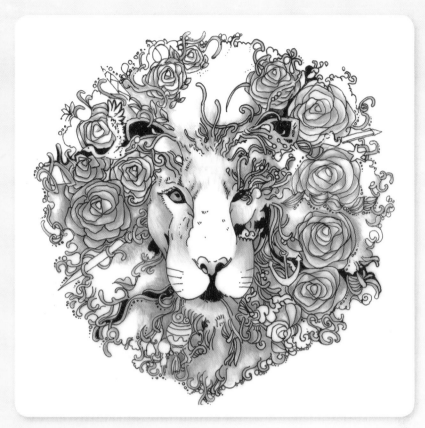

thorns & roses
VICTORIA SCHULTZ GRUNDY

12" × 9" (30cm × 23cm)
Sakura Pigma micron archival ink pen 01 on Dura-Lar (plastic) matte film, colored with Inktense watercolor pencils by Derwent

Lines are everywhere in nature and I love to see the lines in a farmer's freshly plowed rows. In this image, the line drawing in the lion's head was very compelling to me and especially interesting when I chose to interpret things a little differently by adding the roses in the lion's mane.

sometimes you help yourself the most when you help others.

—VICTORIA SCHULTZ GRUNDY

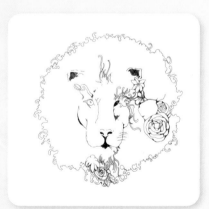

1 Draw or photocopy a lion on matte film so it's translucent.

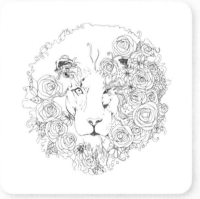

2 Create your line drawing of the lion, leaving an outline that you can fill in with tangles and doodles. Concentrate on your lines, making them as smooth as possible and treating them with care. Darken areas to add weight and some balance to your work.

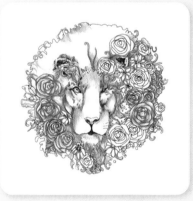

3 Color the work. Make sure you select your color scheme with intent. Choose carefully where you will place colors and how you will marry them with the drawing.

calavera of flowers

DR. LYNNITA K. KNOCH

3½" × 3½" (9cm × 9cm)
*005, 01 and 05 Sakura Pigma black
micron pens and graphite pencil on
2-ply vellum bristol tile*

Dia de los Muertos (Day of
the Dead) is a Mexican holiday
celebrated in the Southwest to
remember our ancestors. The most
common symbols for the holiday are
calaveras (skulls) and bright flowers.
Calavera of Flowers reminds me of
my roots.

*Art is relaxing
and therapeutic,
especially during
stressful holidays.*

—DR. LYNNITA K. KNOCH

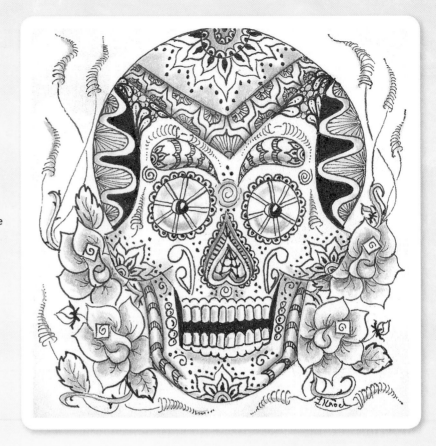

1 Draw the skull outline, adding circles for eyes, a heart for the nose and paisleys for eyebrows. Add the teeth. Divide the skull into more sections if desired.

2 Draw a circle in each eye for the pupil and fill the rest with spokes like a wheel. Outline the eye with crescent moons. Add flowers to the chin, cheeks and forehead.

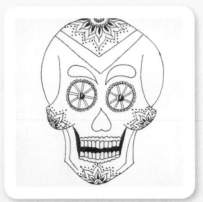

3 Use the Florz grid pattern for the nose. Repeat the nose shape three times and outline it with a crescent moon. Add Pearlz to the jawbone and a deco border to the temple. Tangle the rest as desired. Frame the skull with flowers and Zingers. Shade as desired.

Sign up for our inspiring and free newsletter at CreateMixedMedia.com.

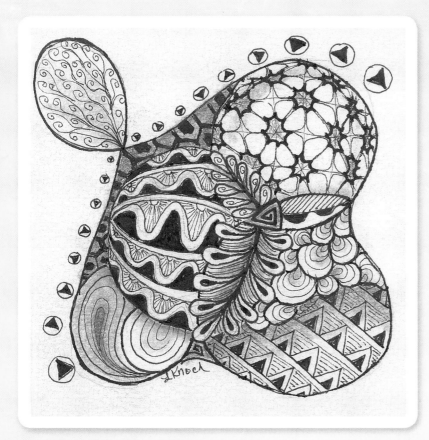

circular Thinking

DR. LYNNITA K. KNOCH

3½" × 3½" (9cm × 9cm)
*01, 05 and 08 Sakura Pigma black
micron pens and graphite pencil
on Fabriano 140-lb. (300gsm)
watercolor tile*

I love the patterns created by
overlapping circles. Depth and
movement are generated by the
circles, especially when shading
is added.

*Art is an adventure
that never ends, just
like circles.*

—DR. LYNNITA K. KNOCH

1 Start with three overlapping circles
of different sizes. Add a smaller
fourth circle below the others. Join
the circles with a smooth, curved,
looping edge, cutting off part of
the largest circle.

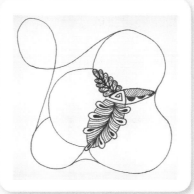

2 Fill in the overlapping sections first;
use a triangular Greek key where
all three overlap and leaf variations
where two circles overlap.

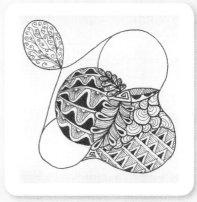

3 Divide the largest circle into
two sections. Fill the top with
teardrops and the bottom
with a Semaphore variation (a
triangular pattern). Tangle and
shade the rest as desired.

Nautilus

DR. LYNNITA K. KNOCH

3½" × 3½" (9cm × 9cm)
005, 01, 03 Sakura Pigma black
micron pens, .005 Prismacolor blue
pen and graphite pencil on 2-ply vellum
bristol tile

I was inspired to tangle a nautilus
after reading CZT Michele
Beauchamp's tutorial on spirals.
Nautiluses are fascinating creatures,
having been in the oceans since
the dinosaurs.

*Be creative, thereby
allowing yourself to
make mistakes.*

—DR. LYNNITA K. KNOCH

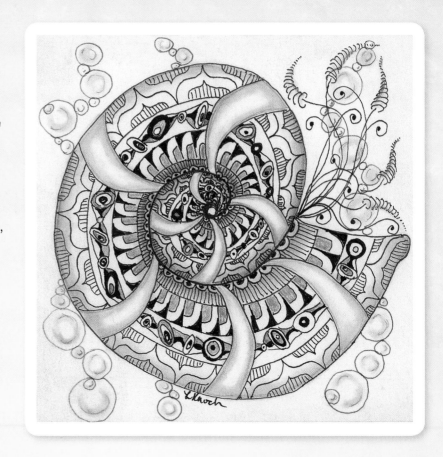

1 Draw a spiral. Divide it into
sections with curved triangles
to give a sense of roundness to
the shell. Divide the sections
into fourths.

2 The first (smallest) section is
filled with Reticulated (half
circles and lines), while the
third section is filled with Cellu
(an organic tangle of circles
connected by lines).

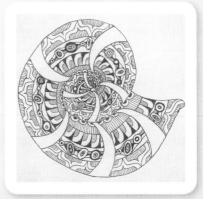

3 The second section has Feagle
(blade-shaped design) tangles,
while the outer section is filled
with a Copada (braces) variation.
Swirls and Zingers extend from the
opening, while blue bubbles were
added to show the nautilus floating
in the ocean. Shade as desired.

Sign up for our inspiring and free newsletter at CreateMixedMedia.com.

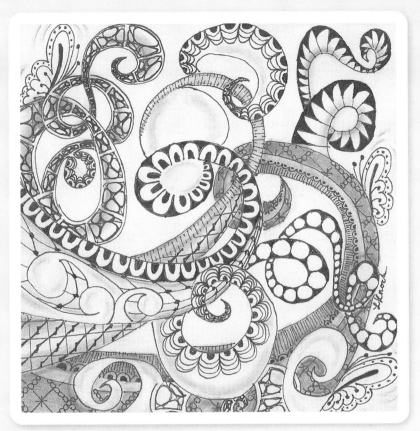

swirls upon swirls
DR. LYNNITA K. KNOCH

3½" × 3½" (9cm × 9cm)
*005, 01, 03 black Sakura Pigma
micron pens and graphite pencil on
white card stock*

Swirls, paisleys and ornamentation
are some of my favorite things to
draw. This string full of swirls—
overlapping, twisting in and out, and
twirling across the page—makes me
want to dance.

*Enjoy the moments by
dancing in the rain,
warming your face in
the sun and standing in
the moonlight.*
—DR. LYNNITA K. KNOCH

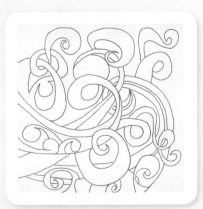

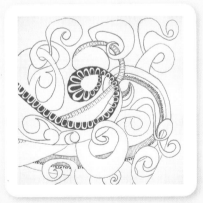

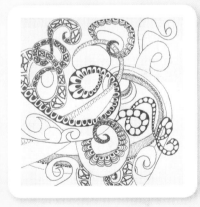

1 Start with three large swirls
overlapping each other. Fill the
page with more swirls inside and
extending from these larger
swirls, twisting in and out of each
other. Divide the larger swirls into
sections along the length.

2 Fill in the smaller sections of the
large swirls first. The top one has
a Mendhi (henna tattoo) design,
the middle one has Sproing
(long and short lines), while the
bottom one has the Reticulated
pattern (half circles and lines).

3 Fill some of the smaller swirls
with patterns like Pearlz,
Crescent Moon and Squish.
Leave others empty (shade only).
Fill the rest of swirls as desired.
Add butterflies and shade.

Arab
MELODIE DOWELL

9" × 11" (23cm × 28cm)
Micron pens of different sizes and pencil on white drawing paper

I love drawing horses! So that was my inspiration for this doodle. When I tangle a horse, I like to try to follow the muscles and the direction of the mane. This tangle won a first place ribbon at a fine arts show. I was totally thrilled.

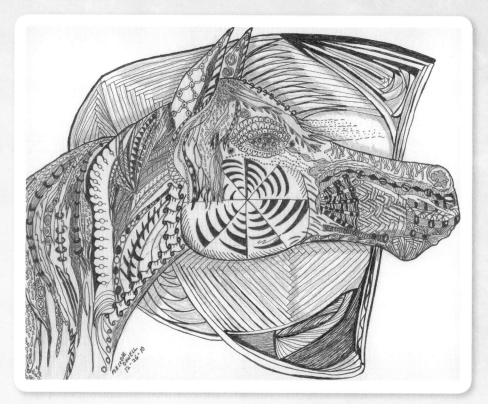

If you constantly push yourself to be perfect, you will always fail. Set smaller goals. Try for contentment and enjoyment. Those are realistic goals. Perfection is not!

—MELODIE DOWELL

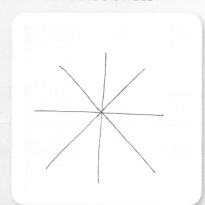

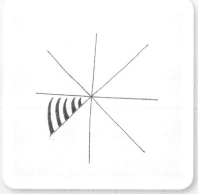

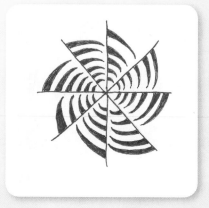

1 | You can start with any size you need. Draw the straight lines. If some are longer than others, that's okay. There really are no mistakes that can't be fixed.

2 | After you draw your straight lines, start near the center of one line and draw a tiny tooth shape. This can be curved or straight, whatever you think looks best. Then draw each one going out a little bit larger than the first one.

3 | Go to the next line and repeat until you have all the lines full of teeth. And you are done!

Sign up for our inspiring and free newsletter at CreateMixedMedia.com.

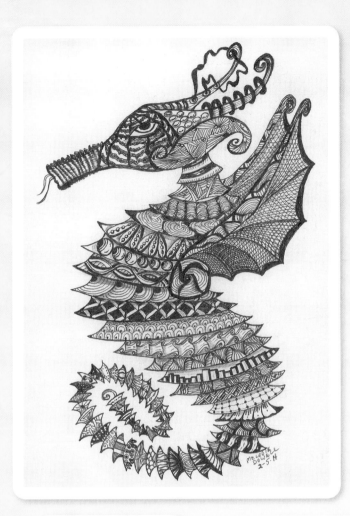

sea Horse
MELODIE DOWELL

10½" × 8" (27cm × 20cm)
Micron and Sharpie pens and pencil on white drawing paper

This little guy just shaped himself as I went along. He was totally unplanned. You just reach a point where you know what it's going to be. I started with the layers of rings. As I got higher, I knew he was a sea horse. So I added fins and a head. He looks a bit angry, but I'm not sure why.

Below, I am showing you one of the most versatile ways to tangle anything. It's called crosshatching. It can be done in so many directions that I could have done the entire sea horse with nothing but crosshatched patterns.

Anyone can tangle or doodle. It's just a way of life. Everyone has already done it, even as a child. There is no failure rate. There are no rules. Just lines. Lots and lots of lines.
—MELODIE DOWELL

1 Start by drawing a simple wing shape. It doesn't have to be perfect. Don't make it hard on yourself. Then make the sections any way you want them.

2 Start with one section and draw your crosshatch lines in one direction. Any direction. From there, just go across that set of lines with another set in another direction. The more times you cross them, the darker that section will be. Make each section different.

3 Separate the sections with a micron 08 pen or a larger, darker pen. Then shade with a pencil. Shading is very important if you want your crosshatching to have interest and depth.

Lover's maze
CURTIS MCWILLIAMS

14" × 17" (36cm × 43cm)
Colored pencil on 96-lb. (205gsm) smooth bristol paper

I never consider my passion as artwork because I am doing what I love. When I create art, sometimes I look for the grains in the paper to guide me, or I draw a flowing line and, like a tree, branch out from there. Most of the time, I see the picture happening as I am drawing it. It is never planned; it just flows from within.

I have a thing for circles and constant flowing energy, spiritual energy and balance. Circles have to be the perfect form; I've yet to see a square or triangular planet or star.

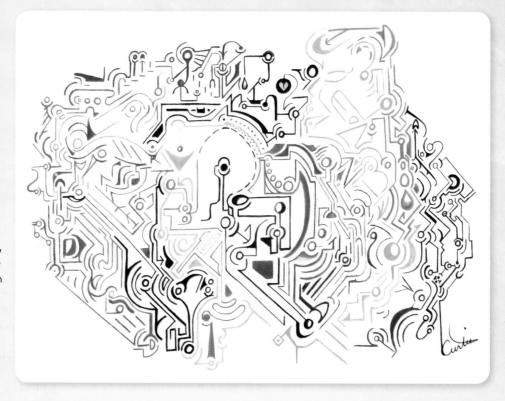

1 When I began this design, I started with a dot in the center of the page. From there, I let the dot lead me.

2 I decided to contain the dot like an eye and let it become a maze. No planned direction, just having fun.

3 At this point, I decided to design a labyrinth-style doodle. You can follow my design or find your own path.

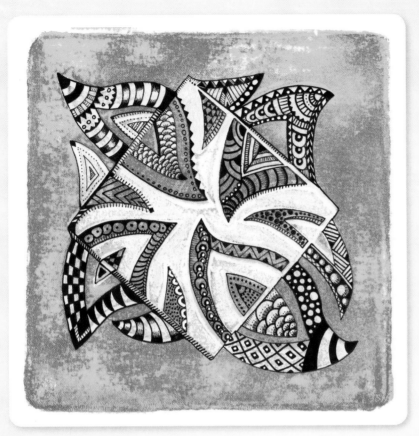

opening out
JOAN BESS

6" × 6" (15cm × 15cm)
Acrylic paint, Copic Multiliner SP markers, white Uni-ball Signo pen, Faber-Castell Pitt artist pen on 110-lb (235gsm) white card stock

I love Gelli plate printing! Many Gelli prints are great beginnings and lend themselves to further exploration. One of my favorite ways to enhance a Gelli print is to doodle into and around its existing patterns. The slow, relaxed pace of doodling is the perfect counterpoint to the fast-paced printing process. Almost any print can serve as an inspiration to embellish with doodled lines and patterns. It's especially conducive when there's a framework within the print to start doodling into.

In art, the hand can never execute anything higher than the heart can imagine.

—RALPH WALDO EMERSON

1 This is a stamp made from cutting shapes from a craft foam square and flipping them outward, then adhering the pieces in place on a contrasting foam substrate. The design is based on the Japanese concept of Notan—involving the placement of light and dark.

2 Acrylic paint is rolled onto a Gelli plate, then the foam stamp is pressed into it and removed. The painted plate is covered with paper and rubbed to transfer the paint, then the print is pulled. Once the print is dry, it's a great surface for doodling.

3 Start by outlining the shapes inside and outside the center square. Fill the shapes with various lines and patterns. Areas of negative space are left blank, defining the original printed shapes.

Visit CreateMixedMedia.com/zen-doodle-oodles-of-doodles for bonus materials.

pinwheels and whirligigs

MARTHA SLAVIN

2½" × 3½" (6cm × 9cm)
Micron pen 005 on card stock

I love whirligigs, pinwheels and any toy that spins. This artist trading card looks like something spinning. Give it a whirl!

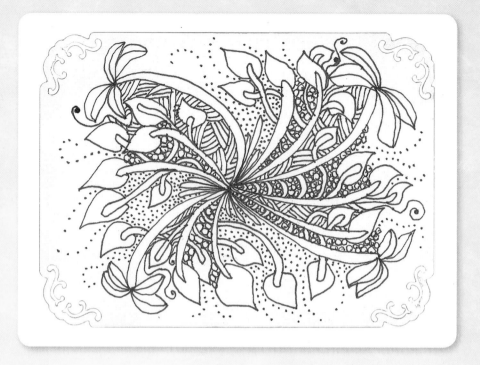

put play in your life and joy will follow.
—MARTHA SLAVIN

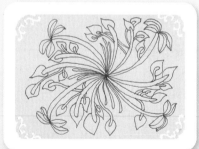

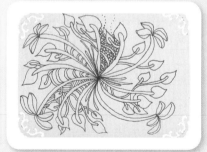

1 Punch the corners with a decorative punch. Mark the center with a dot. Draw the main curved stems in a pinwheel shape.

2 Add more stems to the main stems. Add leaf shapes to the ends of the stems.

3 Draw patterns between the stems. Glue the card to card stock. Fold the long ends to make a card.

Sign up for our inspiring and free newsletter at CreateMixedMedia.com.

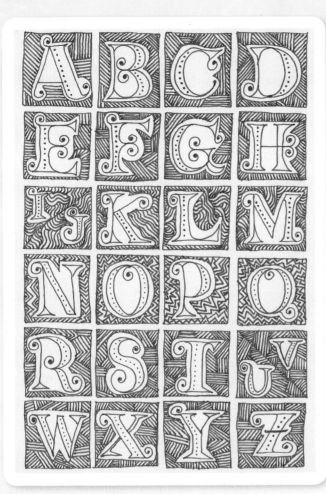

Letterform Lover's Nightmare
MARTHA SLAVIN

5" × 7" (13cm × 18cm)
Micron pen 1.0 on blank postcard

I love letterforms and like to play with alphabets. I turned this easy alphabet into *Letterform Lover's Nightmare* by adding doodles. You have to love Zen Doodles to do all the crosshatching required on this design.

Best handwriting practice: slow down.

—GEORGIANNA GREENWOOD

1 Divide the 5" × 7" (13cm × 18cm) card into twenty-four spaces with a small margin around each space. Divide two squares into triangles. I used I, J, U and V in these squares.

2 Decide whether your alphabet will have serifs, thick and thin lines, or be all the same weight. I used serifs and thick and thin lines. Draw your alphabet in the squares.

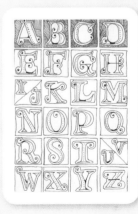

3 Add dots to the letters. Outline each letter. To finish, add crosshatching.

spring is in the Air
MARTHA SLAVIN

3½" × 3½" (9cm × 9cm)
Micron pens 005 and 05 on square doodle card

I have been doodling since I was a child, but I didn't start doing Zen Doodles seriously until I had to spend time waiting for my husband to recover from back surgery during a lengthy hospital stay. Now I carry a pack of Zen Doodle cards with me all the time. I take them out anytime I have to wait. Sometimes while I am working on a doodle, someone comes by and admires my work. I often give them the finished design—my way of doing an Art Abandonment project.

what we see depends mainly on what we look for.
—JOHN LUBBOC

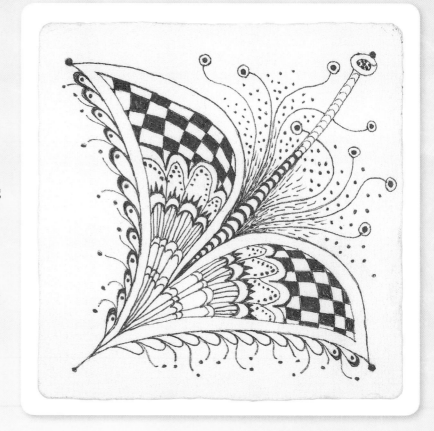

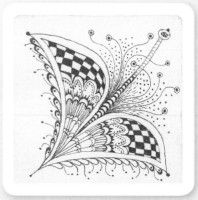

1 | Place dots at all four corners. Start at the left side. Draw curved lines as shown. Draw a border inside each petal shape. Add two small circles touching the right top dot. Draw two parallel lines from the circles to the center of the petals.

2 | Inside each petal, draw four lines radiating from the left dot. Draw sets of scallops using the four lines to guide you. Above the scallops make a checkerboard pattern.

3 | Add details such as waves, squiggly lines and decorative lines in the scallops and on the stem. To complete, fill in the checkerboard, add dots and darken some lines.

Sign up for our inspiring and free newsletter at CreateMixedMedia.com.

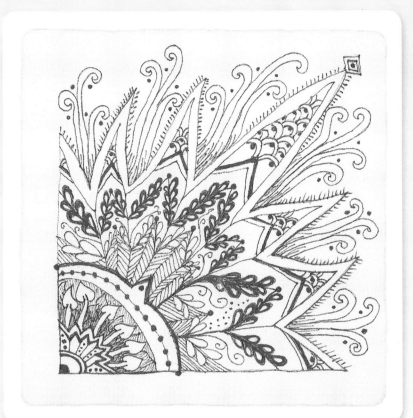

DOT TO DOT
MARTHA SLAVIN

3½" × 3½" (9cm × 9cm)
Micron pens 005 and 05 on square doodle card

As a child, I loved dot-to-dot puzzles. I was always curious what the shape would become. This Zen Doodle is based on that idea.

Find out as much as you can about everything you can. Then practice, practice, practice.
—MARTHA SLAVIN

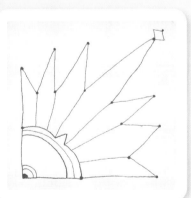

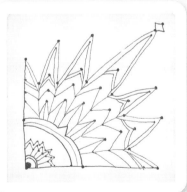

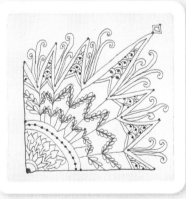

1. Place dots as indicated on the card. Connect the dots. Enlarge the bottom left dot and draw five quarter circles as indicated. Add a diamond to the top right dot. Draw radiating lines from the largest quarter circle to the bottom sets of dots.

2. Draw two sets of dots on the radiating lines. Between the circle and the border, draw three rows of dots. Connect the dots. Divide the first set of zigzags as shown. At the bottom left corner, add three parallel quarter circles of dots. Connect them so you have two zigzag rows.

3. From the small rays at the bottom, draw leaves. Add petals, scallops and vines. Add dots, swirls and hairlines. Darken lines in some areas.

Life Blooming, Life Confirming

MARTHA SLAVIN

3½" × 3½" (9cm × 9cm)
*Micron pens 005 and 05 on
doodle card*

Like many artists, I look for texture
and pattern everywhere I go. If you
see someone photographing a crack
in the cement, that is probably me.
I love the shapes and variations that
I find in nature and in man-made
structures too.

*Happiness never
decreases by being
shared.*

—ZEN BUDDHIST SAYING

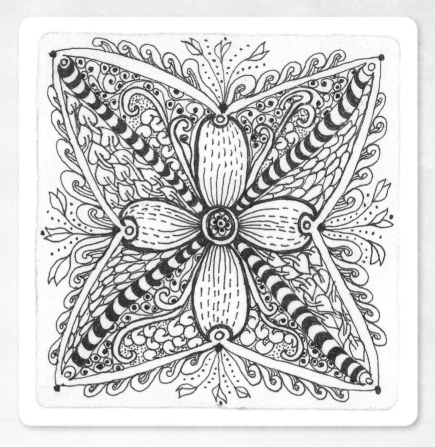

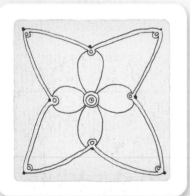

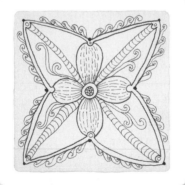

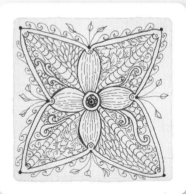

1 Place a dot in the center and
each corner. Draw three circles
in the center. Place a dot about
halfway between the center and
the outside edge on all four sides.
Connect the dots with curved
lines. Draw an open circle at each
point. Add another line inside
the borderline. Draw a curved
line from the open circles to the
center circle to create petals.

2 Draw parallel lines running from
opposite corners. Add details
such as vines and waves. Add
details to the center petals and
to the center circles.

3 Add details such as leaves,
sprouted seeds, swirls with
circles and dots, and rounded
rocks. Darken every other stripe
on the cross lines.

Sign up for our inspiring and free newsletter at CreateMixedMedia.com.

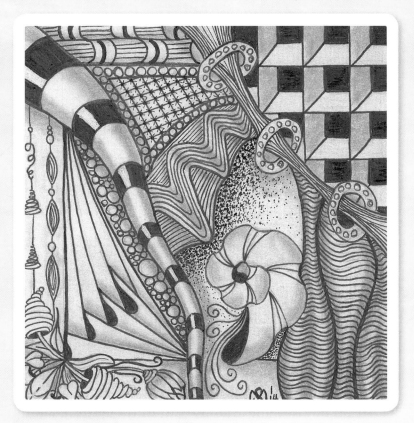

In My Mind's Eye
SCOTT MICHALSKI

4" × 4" (10cm × 10cm)
Sakura Pigma micron pen and graphite Strathmore bristol artists tiles, 100-lb. (215gsm) vellum surface

I was drawn to Zen Doodle because of the bold black-and-white contrast and how it makes the paper look like it has shape and dimension. The relaxing meditative feel of the process was an added bonus for me and is very therapeutic at times.

To those who think they can't draw, you can with Zen Doodle. Just use your imagination and let your creativity flow, one section and one pattern at a time. Soon the page will be full, and you will see art—your art.

—SCOTT MICHALSKI

1 Begin by laying out some lines and shapes to be tangled, dividing the tile into sections.

2 Choose some tangle patterns that fit well into the shapes drawn and begin filling in each section, concentrating on one at a time. I chose some with contoured lines that lend the illusion of shape and dimension to the pictures.

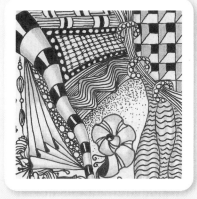

3 Fill in some black color, highlights and shading for contrast and depth. Add some accent doodles to fill in empty space and details to make some sections really pop.

feathers
MOLLY ALEXANDER

3½" × 3½" (9cm × 9cm)
Mixed media on canvas

Flowers and lace are a common theme in my doodles, and this feathery floral piece is no exception. I love to work with bright colors and lots of texture, so these things are worked into this piece through the use of canvas, acrylic paint, transparent and opaque gel and glaze pens.

Never underestimate the value of your own story, and don't be afraid to share it with others through your artwork.

—MOLLY ALEXANDER

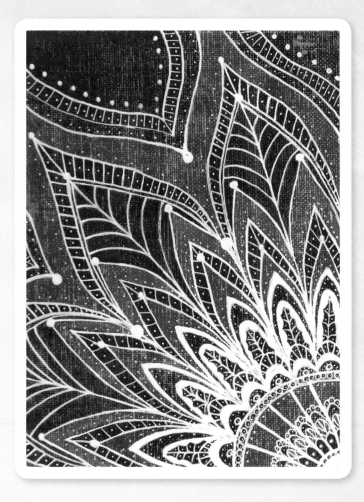

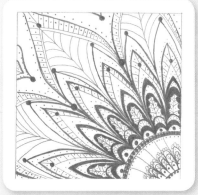

1 If desired, paint a purple wash onto the canvas using acrylic paint. Let it dry, then use sandpaper to accentuate the texture of the canvas and seal it with a fixative spray. Using a graphite pencil, draw in the main elements of your design.

2 Start filling in the larger elements with your doodle designs using a graphite pencil. Using a fine-point opaque white gel pen, draw over the penciled-in lines.

3 Continue to doodle using the fine-point opaque white gel pen. Then, using a thicker opaque white gel pen, go over some of the lines, making them thicker than others and filling in backgrounds behind some of the doodled elements.

 Sign up for our inspiring and free newsletter at CreateMixedMedia.com.

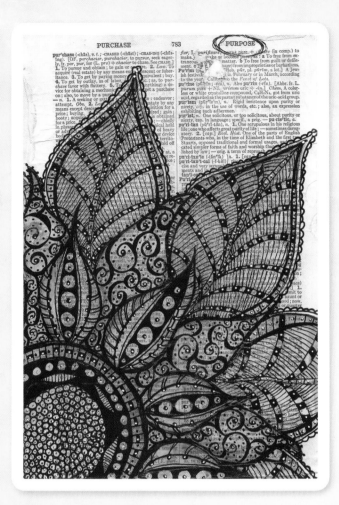

I Have a Purpose
MOLLY ALEXANDER

5¾" × 8½" (15cm × 21.5cm)
Mixed media on ephemera

I Have a Purpose is actually taken from a page in my art journal. I love working with vintage books and dictionary pages because they give instant texture and interest to a design. The word *purpose* is one of my favorites and just happened to be at the top of this page. I started drawing and filling in patterns, and ended up with the finished piece you see here. I love the freedom I have when I doodle. I'm not a huge rule follower, and this art form allows me to wander freely through my mind as I work through the repetitive design elements of a finished piece.

Be authentic when you create.
—MOLLY ALEXANDER

1 Glue down an antique dictionary page, leaving the top side without a decoupaged finish. Using a graphite pencil, draw in the main elements of your design. Then, using watercolor pencils and water, fill in your large elements with the color wash of your choice. Allow to dry.

2 Start filling in the larger elements with your doodle designs using the graphite pencil. Using a fine-point black gel pen, draw over the penciled-in lines.

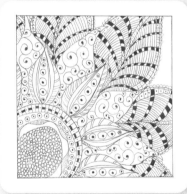

3 Continue to fill in your flower parts with doodles until the picture feels finished. Then, using a thicker black gel pen, go over some of the lines, making them thicker than others and filling in backgrounds behind some of the doodled elements.

Leaf study I
SALLY HARRISON

Staedtler pigment liners 0.1 and 0.05 on cartridge paper

I first started doodling in meetings as an outlet for my pesky little inner artist who wanted to get out of the boardroom and into the sunshine. When I found myself with time on my hands, I bought a sketchbook and some fineliners and just started drawing. After I posted some pictures on Instagram, people started likening my sketches to Zen Doodles, so I did some research, bought a couple of books and then I was hooked.

There is no age limit on being creative. It's never too soon or too late to call yourself an artist.
—SALLY HARRISON

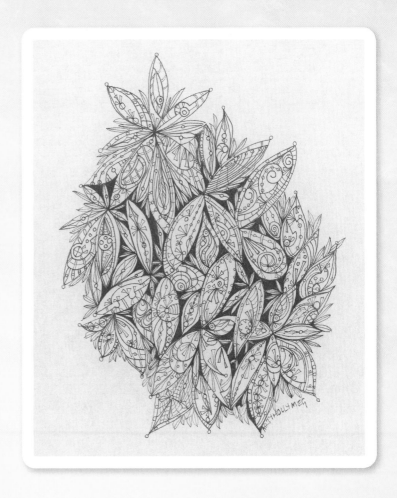

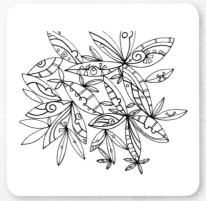

1 | Draw a leaf shape over and over again, piling them and attaching them together in crescents. Use different sizes, including little ones, to fill gaps. Add depth by filling in the final gaps between the shapes with dark shading.

2 | Try out different ways to add lines within the leaf shapes to divide the space. Use circles, curves and straight lines. There are no rules—just aim to make interesting shapes.

3 | Have fun. Add details, more circles and funky little triangles. Have no regard for reality; just let your imagination go.

Sign up for our inspiring and free newsletter at CreateMixedMedia.com.

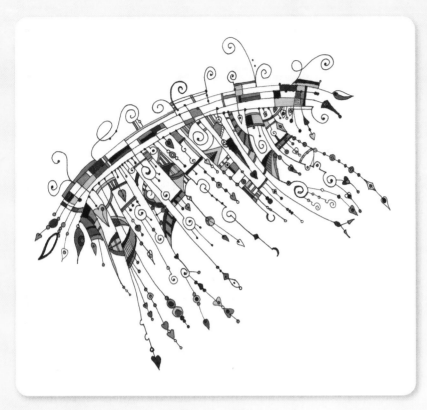

Hanging Jewels 1
SALLY HARRISON

Staedtler pigment liner 0.1 with color

I so love the way abstract shapes can be made to look delicate and almost like jewelry, and this one is my favorite of my dangle doodles. This doodle now travels with me as my iPhone case and in my vintage VW camper van, Nancy, as a funky cushion.

Forget perfection. Play, laugh, giggle, then scribble, doodle and create.

—SALLY HARRISON

1 Start with a lovely arching shape made of different squares and add some simple lines with different curves and spirals going upward. Keep these shorter and occasionally quite wide.

2 Place the down lines, ending each one with a cute little shape: hearts, triangles and curls. The lines should be different lengths and at different distances from each other. These lines are attached together with straight and curved lines to create a number of interesting little panels.

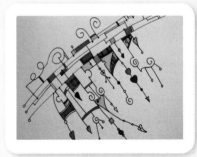

3 Once you are happy with the level of detail, stop! It's very easy to add too many lines and cute shapes. Don't forget to leave some negative space to frame your hanging doodles. Now add some color. You can go for a limited palette, maybe different blues with a bit of orange thrown in for drama, or as I did here, just have a go with each of the pens in the pack.

Honey Dippers
OLGA SCHRICHTE

3½" × 3½" (9cm × 9cm)
Black Sakura Pigma micron pen 01,
HB5 lead pencil on doodle card

Honey Dippers are playful designs
that will add a bit of whimsy to any
doodle. Here they wend their way in
and out of serpentine designs that
were created using Feathered Cs.

You'll never know the
great things you can
accomplish if you don't
at least try.
—OLGA SCHRICHTE

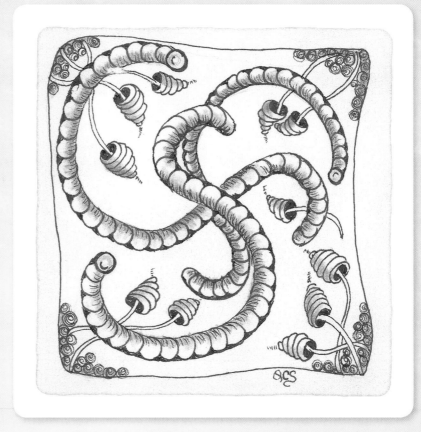

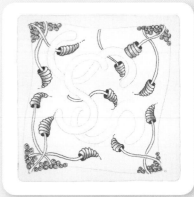

1 | Use a pencil to lightly draw a border. Pencil in several intertwining letter Ss that you will fill in later.

2 | Draw clusters of several slender, gently curving stems. Weave some in and out of the letter S. Draw what look like flattened, rotated letter Cs on top of each stem.

3 | Continue to add wonky flattened Cs until the desired height is reached. Fill in the space around the stem and add dots at the top. Anchor the stems with a mound of teensy-tiny marbles. Shade as desired.

Sign up for our inspiring and free newsletter at CreateMixedMedia.com.

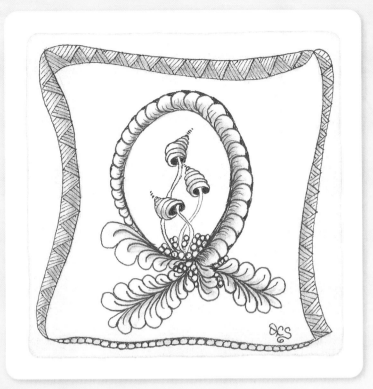

feathered cs
OLGA SCHRICHTE

3½" × 3½" (9cm × 9cm)
*Black Sakura Pigma micron pen 01, HB5
lead pencil on Zentangle tile*

Last year I was introduced to Zen Doodling and was immediately hooked. I was amazed to see I could draw simple, repeatable shapes that magically turned into intricate designs. My inspiration comes from details and textures: the feathers of a bird or the weave in a handle on a basket. This design is named *Feathered Cs* since the Cs form a feathered pattern once connected.

we will discover the nature of our particular genius when we stop trying to conform to our own and other people's models, learn to be ourselves and allow our natural channel to open.

—SHAKTI GAWAIN

1 Use a pencil to lightly draw a border. Switch to a pen to draw a loop, which will be the focal point of the doodle. Begin on the left side and draw a small letter C. Continue drawing Cs around the loop that graduate in size. Anchor them to the loop and back them into one another so they touch.

2 Draw a line along the outer contour of the Cs to connect them. Fill in the V shapes that form between the Cs. Add eyelashes that graduate in size along the inside of the loop. Begin to add a bed of what I call "fish eggs" along the bottom of the loop.

3 Create a favorite motif in the center. Here, I chose something I've named "Honey Dippers." Embellish the bottom of the loop with draping feathered plumes and more fish eggs. Shade as desired.

meandering
RUTH DAILEY

3½" × 3½" (9cm × 9cm)
Sakura Pigma micron pens 01 and 03 on Zentangle tile

Everywhere I look, I see patterns: the bark of my beautiful redwood trees, the petals of flowers, even my garden snail. What fun to build this little microcosm of my everyday world with just a pen and ink. As I become involved, time passes and I meander off to other magical places.

Let your thoughts meander toward a sea of ideas.
—LEO MINNIGH

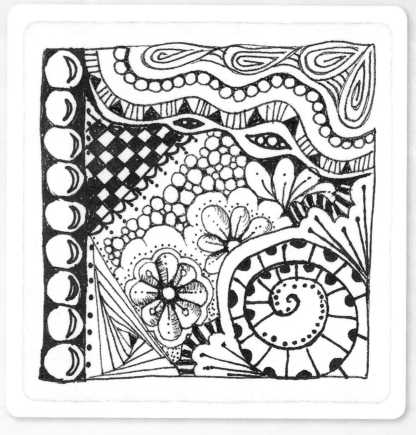

1 Draw a light pencil border. Add the spiral as a thread and the parallel wavy lines. Add large bubble dots in pencil for spacing.

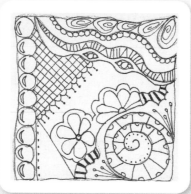

2 With a 01 black pen, ink in the threads and begin to add other patterns. Fill all the spaces.

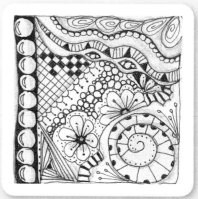

3 Use a 03 black pen to fill the spaces in the checkerboard, triangles, spiral and around the bubbles.

Sign up for our inspiring and free newsletter at CreateMixedMedia.com.

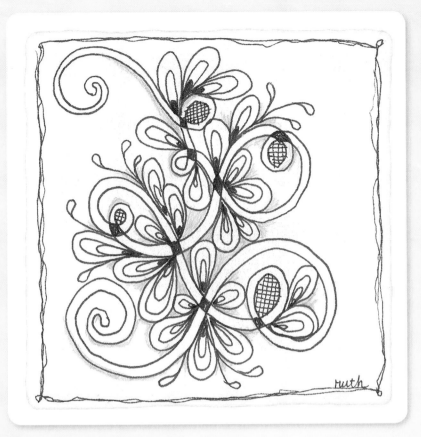

tangled
RUTH DAILEY

3½" × 3½" (9cm × 9cm)
Sakura Pigma micron pen 01 and no. 3 graphite pencil on Zentangle tile

Imagine my surprise in late 2008 when I discovered doodling was fast becoming an international phenomenon—who knew! I had been doodling all my life! Thanks to Rick Roberts and Marie Thomas for the establishment of their Zentangle method where they've proven that anyone can make art "one stroke at a time." I love all the glorious company I have now to doodle with.

if you get tangled up, just stop and smell the flowers.
—RUTH DAILEY

1 Pencil in the border and maze-like string. Double the string to make a loopy path.

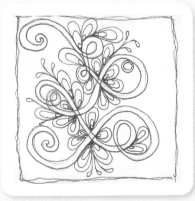

2 Ink in the path and add flower petals.

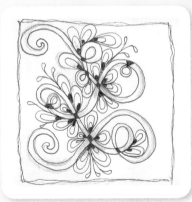

3 Fill little loops with crosshatching and fill intersections with black. Add shading.

valentine flower zen doodle

SUSAN CONNIRY-BEASLEY

5" × 6" (13cm × 15cm)
Sakura Pigma micron pen and Letraset ProMarkers on Strathmore mixed-media paper

From basic Zentangle, I stepped out of the box to Zen Doodle. Doodling allows me to slip into the silence, a place where I feel safe. I love flowers but hate to see them wither and die. So I draw doodle flowers that will live forever! Combining them into a heart shape, I created this piece for my husband for Valentine's Day!

Paint your own picture, choose your own colors and forget all that business about staying between the lines!

—SUSAN CONNIRY-BEASLEY

1 Draw the outline of a heart in pencil. Use a stencil if you like.

2 Randomly draw circles (for flower shapes) and leaf shapes in pencil. This gives you a simple layout. You do not need to fill the whole shape. Spaces can be filled in later.

3 Begin drawing the flowers and leaves, then doodle any other details to fill in the heart shape. Work under and over existing shapes. Erase pencil marks, and color and shade as desired. Add a bird or two and maybe a butterfly.

 Sign up for our inspiring and free newsletter at CreateMixedMedia.com.

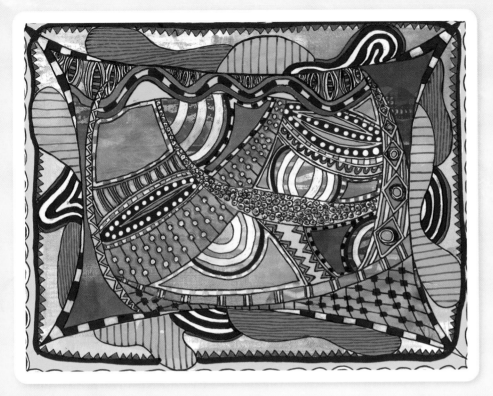

wild
TINA WALKER

8½" × 11" (22cm × 28cm)
*Ranger Color Wash spray,
Montana markers, Sakura
Pigma glaze pens on smooth,
200-lb. (425gsm) paper*

I am new to doodling and
drawing; therefore, I like to
create simple yet colorful
designs. My doodles are
generally random and free-
flowing, and my delicate
patterns are inspired by
the random shapes in my
doodles. Inspiration for
Wild came from wanting to
create a wild-inspired, free-
form doodle full of color,
movement and energy.

*Embrace imperfection. Don't fight it.
Love it!*

—TINA WALKER

1 Loosely draw a drooping rectangle
for the basic outline. Create smaller
sections inside the rectangle by
connecting random sides.

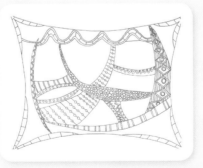

2 Fill interior sections created in
step 1 by adding small patterns
and designs. Keep the patterns
random and imperfect.

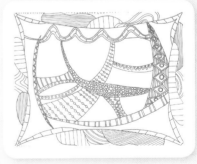

3 Don't forget the outside edge of
your doodle. Draw three randomly
sized shapes on each side. Fill
these shapes with patterns and
repeat the patterns on all four
sides. Continue filling inside
the rectangle with patterns and
designs. Outline the entire doodle.

Green zen envy
TRUDY NOORDMAN

26" × 26" (67cm × 67cm)
Digital art using Sketchbook Pro by Autodesk and Android HP Touchpad

The inspiration for this very popular piece came from my love of my son, music and nature. Zen Doodling brings me to a deep meditative state that brings out the small and important details in the patterns. This piece was complete after five days and almost twelve hours a day of quiet contemplation and precise placement of each pattern.

I am the silence between the notes that make the music.

—TRUDY NOORDMAN

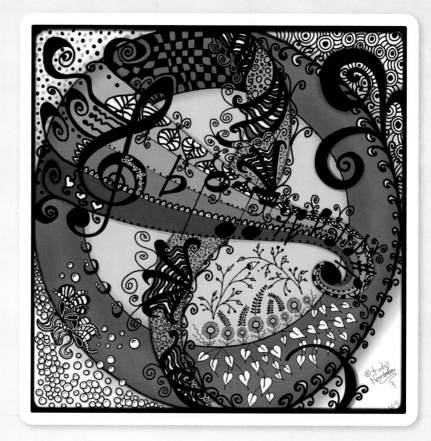

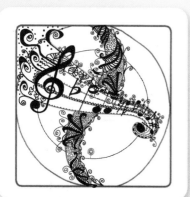

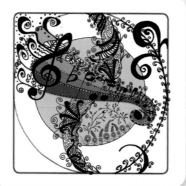

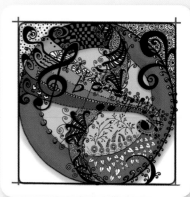

1 Begin with the inner and outer circles. Add waves of shapes and symbols, concentrating on placement as to what appeals to the eye. Be sure to save each step and many copies.

2 Continue to add your own meaningful designs. Love your work, baby it, nurse it along slowly. Practice patience to ensure the final piece is wonderfully captivating.

3 Moving along, be sure to add the shadows for depth and any hidden images and/or words that you'd like to incorporate. While coloring and shading, be sure to keep the direction of your light source accurate.

Sign up for our inspiring and free newsletter at CreateMixedMedia.com.

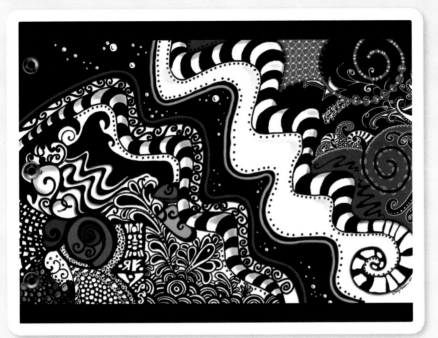

zen madness
TRUDY NOORDMAN

1280 × 960 pixels
Digital art using Sketchbook Pro by Autodesk and Android HP Touchpad

With the record-breaking -50°F (-46°C) winter of 2013, there were plenty of hours to fill with my love of doodling. This Zen Doodle piece is the result of the meditative benefits that Zen Doodle has on an artist trapped inside during a deep freeze.

I've worn many hats. My favorites were the ones worn while loving you.
—TRUDY NOORDMAN

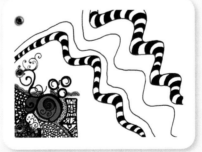

1 | Starting on one side of the art space, slowly fill the entire space with Zen Doodle-inspired patterns and your own ideas as well.

2 | The beauty of digital art is the ability to undo and erase any strokes, shapes or mistakes. You may find yourself experimenting with many patterns and shapes as you go along.

3 | Keep adding more patterns and begin to shade in the areas you choose. This piece was not created overnight; patience and creativity will result in an award-winning image.

KISS—KISS GIRL I
RAE ANN WILLIAMS

6" × 6" (15cm × 15cm)
*Micron 08 pen and Prismacolor
ebony pencil on Bee Paper Super
Deluxe 93*

My first Zen Doodles were done
traditionally by creating a border,
subdividing the inner area and creat-
ing the different patterns. Then I
remembered my mom had always
drawn faces, and that became my
inspiration—why not doodle people?

*visit createmixedmedia.com/
zen-doodle-oodles-of-
doodles for some bonus
step-by-steps from this artist!*

*I am an artist, you
know...it is my right to
be odd.*

— E.A. BUCCHIANIERI

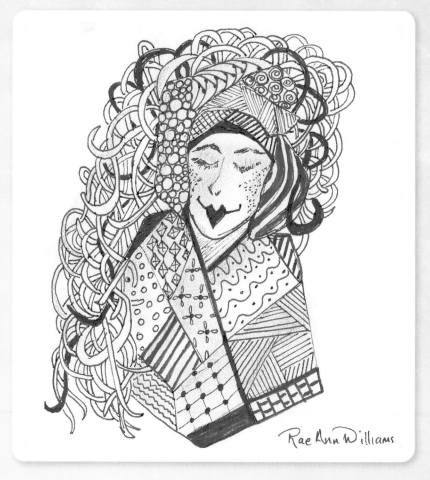

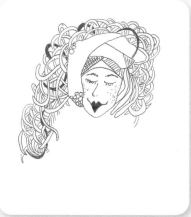

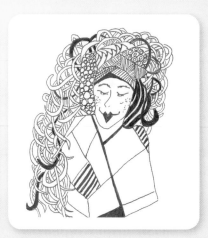

1 | Start by drawing the face,
making downward-facing eyes
and a heart for lips.

2 | Do the doodles for the hair and
the headband. Add the kimono,
then subdivide and doodle.

3 | Use an ebony pencil for shading.

Sign up for our inspiring and free newsletter at CreateMixedMedia.com.

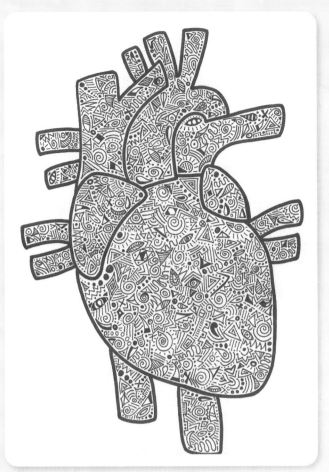

A COMPLEX HEART WITH A HIDDEN KEY

STEPHANIE MELISSA DORSAINVIL

11" × 8" (28cm × 20cm)
Regular Sharpie and thin Sharpie on paper

My inspiration for this piece was to show some of how my heart feels. Black and white—simple yet filled with many details—complicated. So, simple yet complicated. And the hidden key is found only by people who pay close attention.

The hells we have lived through and live through still have sharpened our senses and toughened our wills.

—MAYA ANGELOU

1 Start by sketching an outline. Then, using a bold marker, outline it.

2 Begin filling in the heart with doodles. Add lines, triangles, dots, swirls or anything else that you see fit. Keep them on the smaller, detailed side.

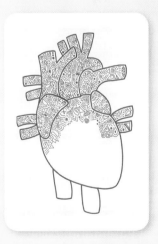

3 Continue filling in the heart. Place the key anywhere you'd like, just don't make it obvious (too big or too little). You want people to work to find it.

ghost girls
KARA LC JONES (MOTHERHENNA)

4" × 4" (10cm × 10cm)
Micron pen and pencil on sketchbook paper

In the book *Yoga for Your Brain*, I saw a piece that was meant to be little whalebone good luck charms in a Zentangle circle. I have a particular interest in Day of the Dead and skeleton shapes, and when I saw the outline of the bone figures, I wanted to take it more literally to the skeleton shape. Having made lots of sugar skulls and skellie stamps for Day of the Dead, I could easily see how to adapt the idea. Inside the circle, I wanted to explore the theme of art of the "heART." When creating Day of the Dead works, we often talk about remembering dead loved ones, how to let our hearts speak of continued love for them, and the beauty that lives on as part of their legacy. I'm trying to capture all of that in this piece.

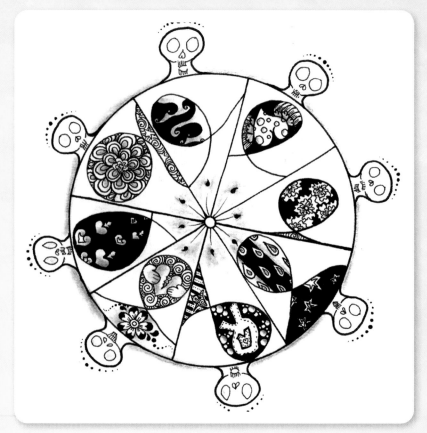

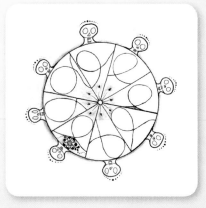

1 Use a circle stencil to create the outer larger circle and inner center circle. Then freehand the open circle/oval shapes of the tops of the skeleton heads with swooped lines to connect the jaw to the outer circle. Add further embellishments.

2 Use a ruler to make a pie-shaped sectioning from the small circle to the larger circle. That breaks the image down into smaller sections.

3 Do loop-de-loop shapes inside each pie section. Then, rather than fill in the entire pie section, fill in the loop and bottom of the loop with patterns. Explore different images and themes as you doodle the rest.

Sign up for our inspiring and free newsletter at CreateMixedMedia.com.

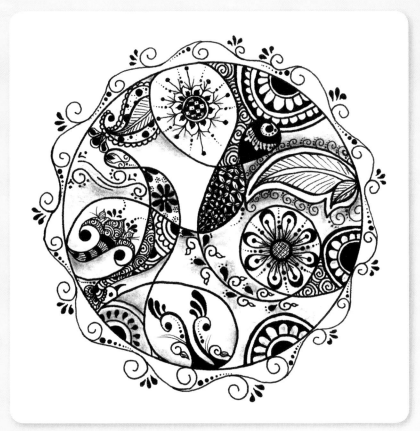

Henna Brim
KARA LC JONES (MOTHERHENNA)

4" × 4" (10cm × 10cm)
Micron pen and pencil on sketchbook paper

I've been practicing henna body art since 2003, and when I first came across Zentangle works, it struck me how very much this style came out of a henna lineage. So with this particular piece, *Henna Brim*, I really wanted to explore some of the traditional henna-style images you see in India, especially in bridal henna. All the shapes and patterns that fill this piece are ones I access over and over again in my body artwork, too. My instructional tiles show a close-up illustration for one of the elements.

1 Do the circle for the center and then surround it with teardrop-shaped petals. Go over the round end of each petal to make the stroke heavier there.

2 Fill the center circle with a crosshatch pattern like a big X and O board, filling each square with a dot.

3 In the center of each petal and in between each petal, draw a line and top the line with a large dot. Top the large dots of the in-between lines with smaller and smaller dots so they trail off. Do a few small lines at the bottom of each line to fan out like blades of grass or small leaves.

serenade
KAREN IZZI, PHD. CZT

3½" × 3½" (9cm × 9cm)
Micron pen 01 and no. 2 pencil on Zentangle tile

As a stylist and metaphysician, I am naturally drawn to elements that are healing. Doodling is a creative healing art that helps us create balance for the mind and body. The time and energy that we spend creating and coloring is vital to our wellness. Through sharing art and making art, we become spiritual and whole.

A creative spirit exists within each one of us. Breathe in every little thing that inspires you. Unmask your brilliant light onto the world.

—KAREN IZZI, PHD. CZT

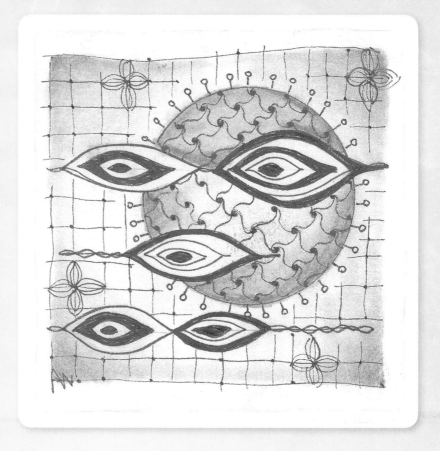

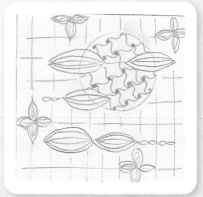

1 | Begin with a shape. I personally don't usually use a shape, but a random string with doodling. You can always mix it up.

2 | Use string lines to create patterns, alternating in the background and foreground.

3 | Use any embellishment for the background. This one is enhanced with flowers.

Sign up for our inspiring and free newsletter at CreateMixedMedia.com.

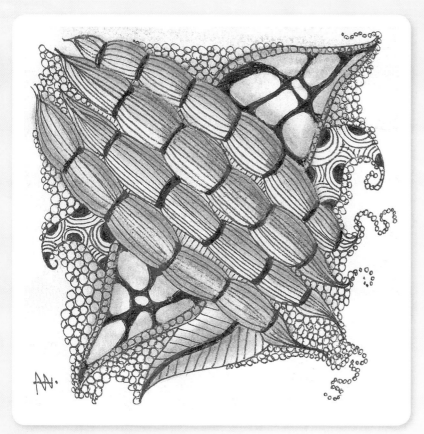

Abundance
KAREN IZZI, PHD. CZT

3½" × 3½" (9cm × 9cm)
*Micron pens 005 and 03 and no. 2
pencil on Zentangle tile*

First thing in the morning, I rush
to my journal. I release everything
in my head to create and explore.
Some days I add color, and some days
I simply rejoice in the simplicity of
black and white. I consciously enjoy
every minute of this pen-to-paper
meditation each and every day, with at
least two cats joining me at the desk.

*Go with the flow,
allowing the creative
current to carry you
and move through you.*
—KAREN IZZI, PHD. CZT

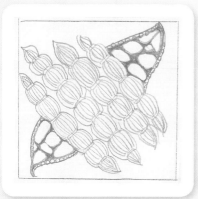

1 Begin this design with some
cheerful cords. Enhance them
with some leafy objects.

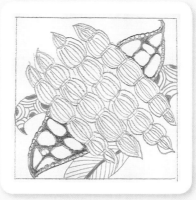

2 Embellish using your favorite
patterns.

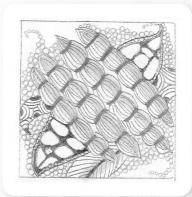

3 Add shading.

Given
KAREN IZZI, PHD. CZT

3½" × 3½" (9cm × 9cm)
*Micron pen 01 and no. 2 pencil on
Zentangle tile*

Being creative means that we see
things a little bit different. Always
follow your heart. Listen to the little
voices and breathe no matter what.
Wait until you see what appears in
front of you. Art can be whatever
you want it to be.

*Take time to
balance and center
yourself. You have
everything you need
to create what
you love. The world
needs more love.*

—KAREN IZZI, PHD. CZT

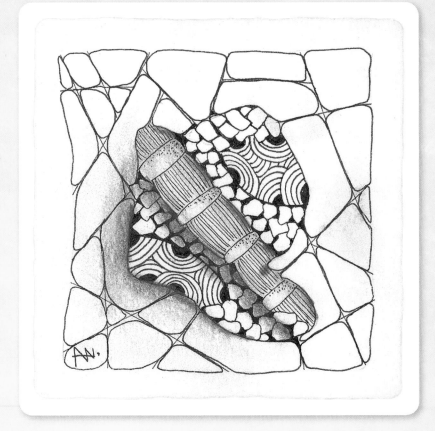

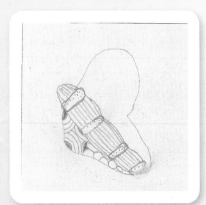

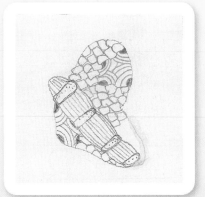

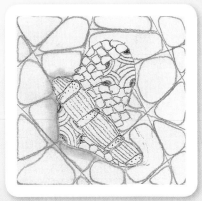

1 Start with an abstracted shape.
Begin by adding patterns that
complement one another. Many
of my designs are earthy and
anthroposophical looking.

2 Keep the background clean and
simple to draw the eye inward to
the actual design.

3 Complete the design with
shading if you desire. Always add
a unique signature to your work.

Sign up for our inspiring and free newsletter at CreateMixedMedia.com.

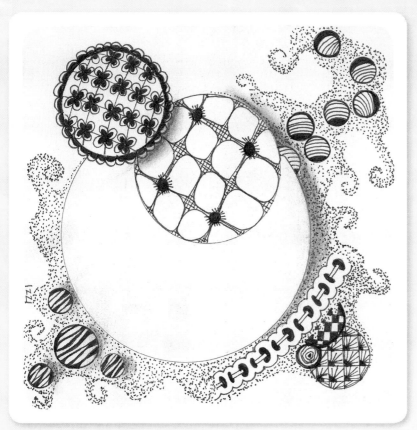

why not fly
KAREN IZZI, PHD. CZT

4" × 4" (10cm × 10cm)
Micron pen 005 and no. 2 pencil on Zentangle apprentice tile

The act of doodling quiets my fears and pours joy into my soul. Be content with what you have and rejoice in things exactly as they are. We are perfect and whole in every way.

Let intuition be your artistic guide. Just listen.
—KAREN IZZI, PHD. CZT

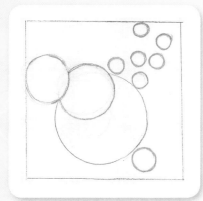

1 This design is made up of simple circles.

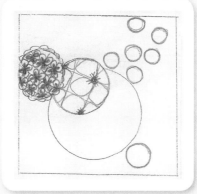

2 Fill the circles with doodle patterns.

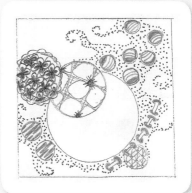

3 Enhance with doodle patterns outside the circles.

silence
DAWN HOWELL

20" × 30" (51cm × 76cm)
Faber-Castell Pitt pens and graphite on foamboard

When I create art, it's hard for me to conform to any rules. When I discovered Zen Doodle, I found it put me in a very meditative state. All your concentration goes into what you are creating—almost like hypnotism.

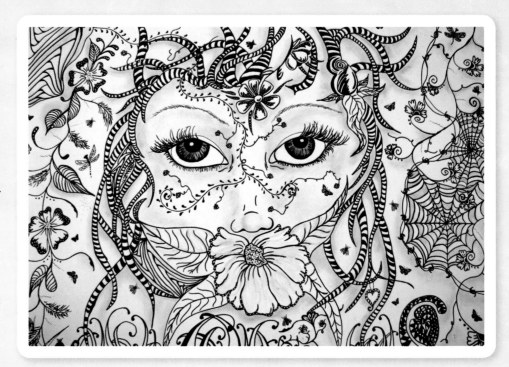

The most important thing you can do is to make one mark...then keep going!

—DAWN HOWELL

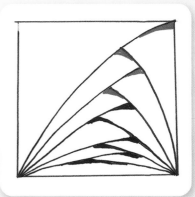

1 Draw a slightly curved line from the bottom left corner to the top right corner. Then draw a slightly curved line from the bottom right corner as close to the top of the first line as you can.

2 To give some dimension, you can slightly flare out the part where the lines meet.

3 Keep drawing lines from corner to corner in a stacking-like motion until you can't make any more. Then shade as desired.

just create
CHRISTINE REYES

3½" × 3½" (9cm × 9cm)
Zentangle Inspired Art on high-quality mixed-media paper

My doctor suggested doing something where a screen wasn't involved. I picked up my old sketchbook and just stared at it. Nothing came to me. I set it back down and played around on Pinterest, where I discovered a pin of cute patterns drawn on rocks. Using ink in my sketchbook, I made my own rocks. I drew different shapes and used some of the patterns I saw online and just made some up as I went along. It took me completely out of the world and muted any noise or distractions around me. It wasn't until a few months later that I discovered that what I was doing is called "Zentangle."

Don't think, just create.
—CHRISTINE REYES

1 Print out *Create* in a font you like and trace it onto your paper. I put it up against a window with light coming through it. Draw your string with either pencil or pen.

2 Fill in your string using patterns you like. I used several patterns including Sanibelle and Mist.

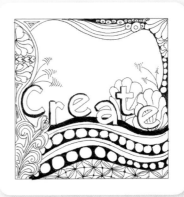

3 Embellish where needed. Add shading and highlights.

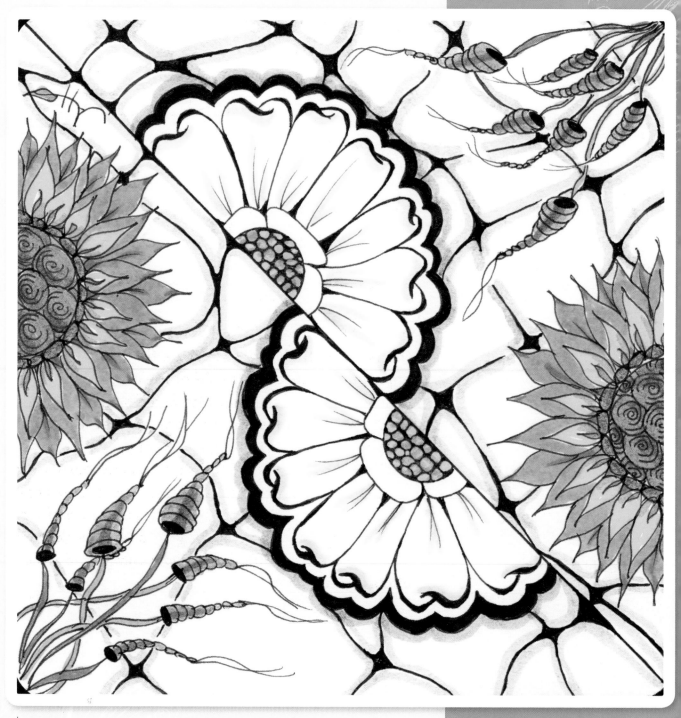

Flora
ALICE HENDON, CZT

part two

zen Doodle Artists illuminated

Now that you're filled with great doodling ideas from the works in the first section, we thought you might enjoy getting to know several of the artists a bit more by learning about their favorite Zen Doodle materials, where they draw inspiration from, at what level they see themselves artistically and more.

Each of the artists in this section generously took the time to answer our series of questions, and we hope you find their insights encouraging, helpful and inspiring.

You can find additional insights and artwork from other artists at CreateMixedMedia.com/zen-doodle-oodles-of-doodles.

alice hendon, czt

What inspires you to create your art?

My art includes a lot of organics—gardens and underwater scenes. I grew up in Newfoundland where flowers were few and far between and ocean life teemed in abundance. Some of my best memories of my dad are of the two of us studying underwater photo books we borrowed from the library. A lot of my drawing today stems from those early days as a child.

What are your favorite Zen Doodling materials?

My heart cries out for bright, vivid, lively color! I find myself making background after background with Dylusions ink sprays, which I then tangle using a Sharpie fine-point pen and a Faber-Castell Pitt artist pen. For shading I prefer a sharp Koh-I-Noor Hardtmuth Progresso 6B pencil and a tortillion; highlights come courtesy of a white gelly roll 08 pen from Sakura. My primary stash is rounded out with Peerless watercolors, Derwent Inktense pencils and Wink of Stella glitter markers.

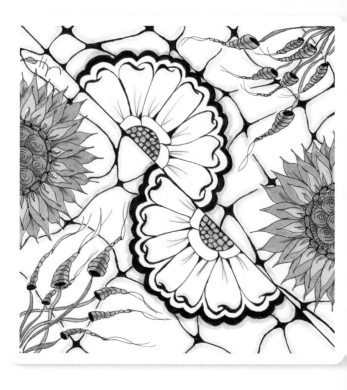

Do you have a standard artistic process? If so, what is it?

Recently I have begun projects by drawing a series of spirals. They really get my brain flowing and my hand moving the pen across the page. I am trying to focus more on using just a handful of patterns at a time, allowing myself to be comfortable in the knowledge of those few before I move on to newer ones. I have a Pinterest board where I keep track of beautiful colors, with lots of shades and hues. If I am going to incorporate color, many times I will review my Pinterest board before deciding which way to proceed. And, of course, there is always my fallback to bubblegum pink and fresh lime Dylusions ink spray colors.

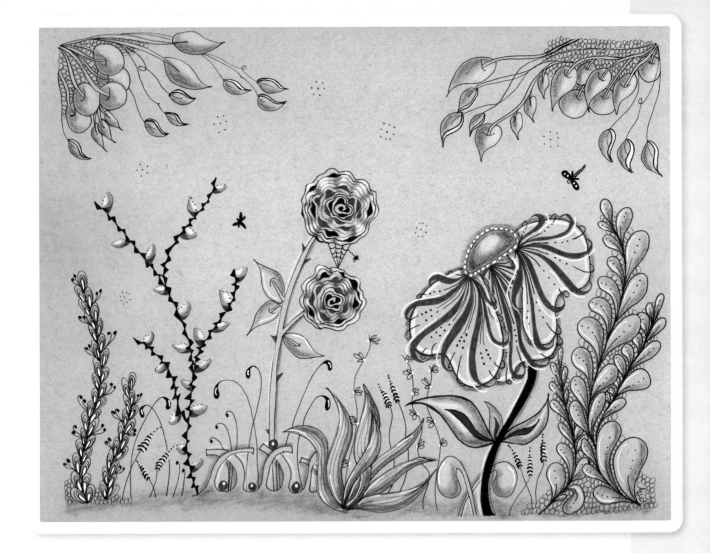

What tips would you give to fellow Zen Doodling artists?

Use quality paper and a good permanent pen to draw with. Your art is an outpouring of your heart, and it deserves the best quality you can afford. Focus on three or four tangles and really allow yourself to explore and know them well before you add in other tangles. Become an expert on those that feel comfortable flowing from your hand.

Do you ever give yourself doodling prompts?

Occasionally I give myself a prompt. Typically, though, I find prompts by way of weekly challenges offered on art blogs and Facebook art pages.

List four things you're inspired by and four things we'd find on your artistic/studio table.

I am inspired by the world around me—by its color, by the changing shapes in nature and by the warmth and coolness of every day. On my art table, you will always find a huge assortment of pens and pencils, paint pens and water brushes, several bottles of Dylusions ink spray and an array of markers.

What is your ultimate goal for your art?

I draw because it makes me happy. It calms my spirit and keeps me balanced. Ultimately I would like to put together a series of books featuring my own tangle patterns in full, glorious color!

barbara simon sartain

What inspires you to create your art?

So many things inspire me! It could be another artist's work, a new technique or a new color combination. I have to say, the butterflies of excitement that happen in my soul when I start to learn something new keep the inspiration to create fueled!

What are your favorite Zen Doodling materials?

A paper with a hard finish is my favorite. My first choice is Canson's Comic and Manga drawing pad, 150-lb. (320gsm). But if that's not available, I would choose a good heavy cover stock. I prefer to use Prismacolor markers and pens and micron pens. The nib and ink always perform the longest, especially the black pens, which have a good solid dark color.

Do you have a standard artistic process?

When deciding on an idea, I like to have a variety of different images in my head before drawing it, whether they come from searching books, the Internet or art created by others.

What tips would you give to fellow Zen Doodling artists?

Have all your supplies ready once you start drawing. I found that if I have to stop and go search for, let's say, another pen weight, the repetition of drawing the pattern gets broken. Never mix your new pens with the ones you are currently using. When I first started doodling, I went on a pen-buying frenzy and ended up with a mess of good and bad.

What made you want to doodle these designs?

These designs were all inspired by nature and animals. The first sight of butterflies is a sign that spring is here. My *Dove and String* was created for my friends who knit and crochet. I love to felt with wool, so *The Sheep* came from that inspiration. While I was sitting on the porch one day, a huge turtle was making its way toward the creek. I noticed how amazing its shell looked. The *Giraffe and Baby* was commissioned for a collector; it depicts the love between a mother and child.

How did you become an artist? How old were you?

I feel like I've always been (or wanted to be) an artist. Creating something—whether crafting, gardening or cooking—has always been my outlet for relaxation. In my late thirties, I started discovering mixed-media art and fell in love. Just the learning process in itself sparked something inside that I really didn't know was there, and it's now a driving force for me to create and learn daily.

Do you ever give yourself doodling prompts?

Art supplies are my prompts. Sometimes I'm going in a particular direction that I want to create a certain piece with and before I know it, I've made a 360° circle into a totally different medium or technique.

List four things you're inspired by and four things we'd find on your artistic/studio table.

Nature, fiber, color, texture

Seeing that I'm ASO (Art Supply Obsessed), you could find most anything on my art table. From pens to raw roving to created felt. But there are always those most important tools: scissors, pencils, pens, erasers and lots of paper for sketching out the drafts for a new project.

What is your ultimate goal for your art?

To continue learning and do good work to share with others, always remembering the only limitations in creating my art are the ones I put on myself.

catherine langsdorf

What inspires you to create your art?

My art seems to be driven by an inner desire to create. Time in my studio helps to quiet myself and centers my life. There are many times when I get into a meditative zone and can close out all the distractions of a busy life. It is the process itself that inspires me to create. Inspiration to create a specific thing of art can come from a variety sources. I never know when something will spark an image in my mind's eye. Once there, the image takes time to simmer and to develop into a finished piece. Then the challenge is to find time to put pen to paper and let my hand execute the design.

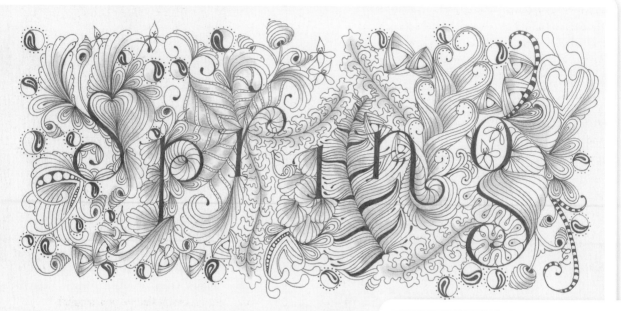

What are your favorite Zen Doodling materials?

Currently, I really enjoy the look of a midtone paper (gray or tan) with a black design and white highlights. I use a white charcoal pencil and an artist stump to lightly shade the image created by black lines. My two favorite pen sizes are the Sakura Pigma micron 01 and 005. I like the small details I can create with these small sizes.

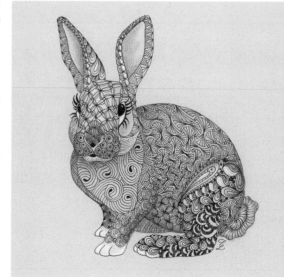

Do you have a standard artistic process? If so, what is it?

There are two aids that I find helpful when creating a more complicated image: running copies and using tracing paper. When a detailed piece has started to build, I do get concerned about ruining the piece. After investing so much time in a project, I stress about making a mistake. I find that this frame of mind blocks the artistic flow. To help me relax, I run a copy of the original and then work on the copy to try out ideas. In addition, I use tracing paper to help me try out doodles in various places on the image. I continue to create and experiment with the design using these two aids. Once I have a direction on how to complete the design, I return to the original drawing with more confidence.

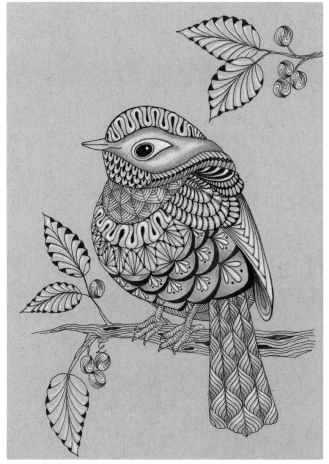

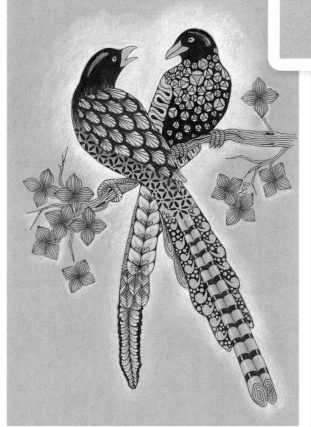

Do you ever give yourself doodling prompts?

As far as a prompt or a challenge, these just seem to come up in the normal course of life. It can be an event, a holiday, a quotation, a thread on Facebook, a response to another artist or a picture in a magazine. Prompts seem to be everywhere. I do find my art is stronger when I have a genuine connection with the prompt. My desire to complete such a piece is intense when there is a personal attachment to the image. Several of my designs are based on the prompt "Peace." I think art has the ability to help others search for what is important and help them ponder their position on issues.

cathy cusson

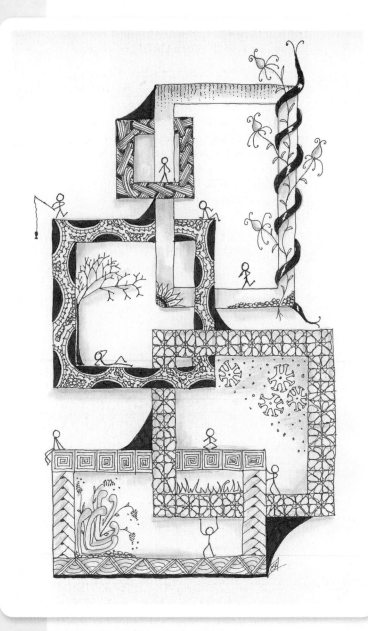

What inspires you to create your art?

Inspiration is all around me. I love looking at others' artwork. I find inspiration in the beauty of nature. Some of my strings for tangling have come from sidewalk cracks and stains! It is there; you just have to use your artist eye.

What are your favorite Zen Doodling materials?

I love the Sakura micron pens! They are so precise. Mostly I use the 01 size to draw with and one of the larger nibs to fill in areas. Occasionally I use color. I enjoy the Sakura gel pens and Koi watercolor markers. Since I draw so much, I usually use an inexpensive heavy card stock cut to the size I want.

Do you have a standard artistic process? If so, what is it?

I try to use doodling as a relaxation tool. As I draw, I find myself working through the stress of teaching or other daily frustrations. It helps me stay focused and calm. Once I decide on an idea, I use a pencil to lightly draw my string. Then I simply let my favorite tangles and my pen take over. One of the things I love so much about this art form is that it really does not take a huge amount of planning. You can relax and enjoy the process of drawing. That is also one of the best things about working in black and white. It takes away the need for planning color combinations.

Do you ever give yourself doodling prompts?

I have a fascination for ABC books, so a favorite thing I am working on is a collection of ATCs (artist trading cards). Each card has one letter of the alphabet, and I use only tangles that begin with that letter. I may mount and display these as a poster for my classroom when I finish.

I also enjoy using pictures from coloring books and the Internet as templates. It can be fun to pencil a landscape from a photo or magazine and fill that with doodles.

Sign up for our inspiring and free newsletter at CreateMixedMedia.com.

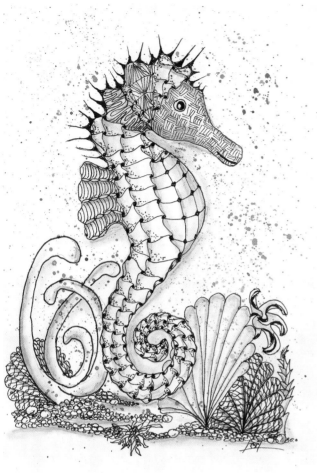

List four things you're inspired by and four things we'd find on your artistic/studio table.

One of the things I love best about this art form is the lack of supplies it requires. While I use other art forms, they generally need a lot of setup and cleanup. Without having a real studio space, that can be difficult. When working on my tangles, the most prominent thing on my table is my notebook. I have a large three-ring binder that houses my collection of tangles. Other items include my boxes of pens and pencils, some watercolor paints and my computer. Behind me on a shelf are my books for inspiration.

What is your ultimate goal for your art?

I have three goals that are important to me. The first and most important is to find an inner artistic peace or enjoyment from what I do. I create for myself. My second goal when creating is to share my gifts with those close to me. I love doing things for others to enjoy. My final goal would be to use my talents to create additional income after I retire from teaching.

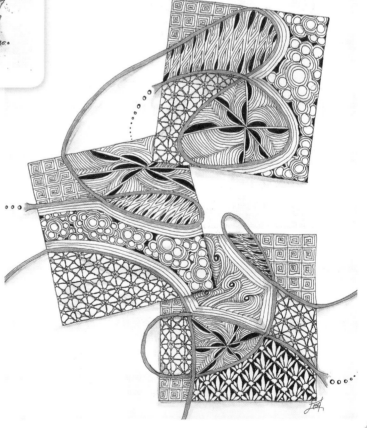

deborah a. pacé

What inspires you to create your art?

I think it is something that has always been in me. I am one who cannot sit still and always needs to be doing something, so creating art is a great way to use up all that energy inside me waiting to get out.

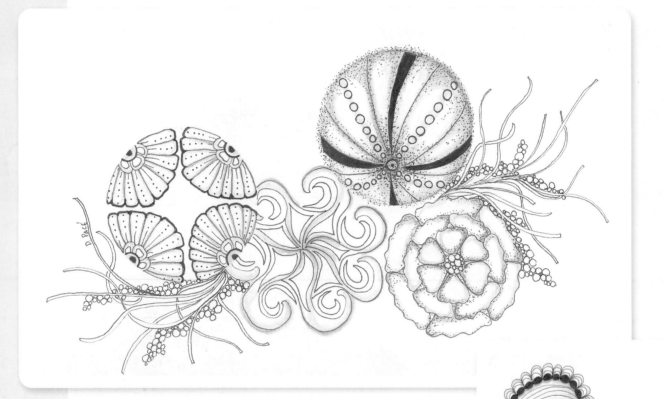

Do you have a standard artistic process? If so, what is it?

I want to say my artistic process is unusual compared with other artists, but I'm thinking I might be wrong. I like to take the whatever-mood-I'm-in approach. I may have a plan the night before or even that day, but when I sit down and start, the idea takes a life of its own, and I am led down another path. I don't fight it; I just go with it and see where it takes me. I find if I do that, I am much happier with the outcome of my design.

What tips would you give to fellow Zen Doodling artists?

Have fun with whatever it is you are doing. Don't stress about it, don't overthink it, just have fun and play. Push your artistic creativeness and ask yourself, "What if?" "What if I try this" or "what if I try that?" See what other artists are doing and try it, but make it your own and never, ever stop at the ugly stage.

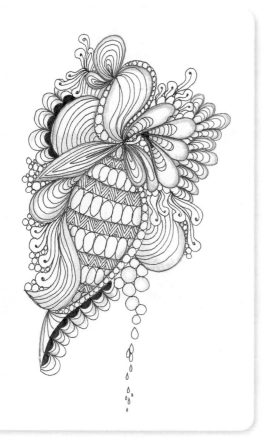

What made you want to doodle these designs?

It was one of those what-if moments. I wanted to see what I could come up with if I just let my imagination take over and not overthink it and try something new. I like doing more abstract, so for me, my doodle designs are, a lot of the time, just having fun.

How did you become an artist? How old were you?

I have been creating since I was five years old when my mother handed me a ball of yarn and a crochet hook. I stayed mostly in fiber arts until recently but have always been doodling, trying to come up with designs for my fiber art. Once I started with Zen Doodling, my creativity soared. For me it has been very freeing and an enjoyable creative expression.

Do you ever give yourself doodling prompts?

Yes, actually, I have. I decided one day to do circles just to see what I could come up with. I have also used a spider web, incorporating it into my design element, and I have even used a name to start my doodling.

Tell us a Zen Doodling prompt you'd like to share in the book.

With *Moon Flowers* I let the design of the paint tell me what to do. I did not overthink it; I just put the pen down and made a mark and then another until the design started to emerge. I think going for it is the best way to start and then see what happens.

List four things you're inspired by and four things we'd find on your artistic/studio table.

Nature, words, weather, artistic visions ("what if")

Sewing machine, fabric, pens/paints (all kinds), paper (all kinds), stuff. (I had to throw in that fifth one.)

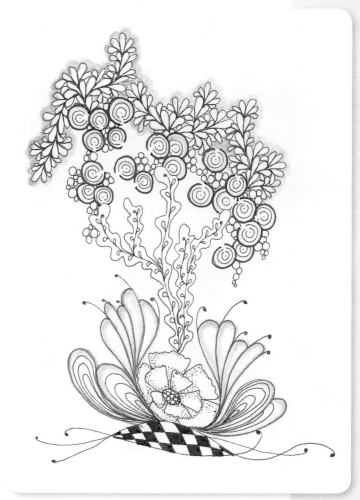

eden M. Hunt

What inspires you to create your art?

Art seems to happen to me whether I do it consciously or not, and I tend to be happier if I give it an opening of one kind or another. If I get busy with the business of everyday life and forget to give that creativity an outlet, I find myself carving shapes out of fruits or arranging vegetable sculptures while I prepare dinner or some other crazy thing like that. My whole journey into doodling began during one of those times. It is an easily portable art form, and the small size of most pieces means that you can complete a piece in even a few stolen minutes. Perfect for where I am in my life right now.

What are your favorite Zen Doodling materials?

I am an on-the-run doodler, so I value the portable nature of this art. I like to keep my work in sketchbooks because it is protected, and I have filled several over the last few years. I like the Strathmore Visual Journals particularly well. The texture of the bristol smooth paper takes ink and pencil shading well, and the ring binding makes for a convenient surface even when drawing in my lap. I like the fine micron pens and have had good results with Pitt artist pens as well.

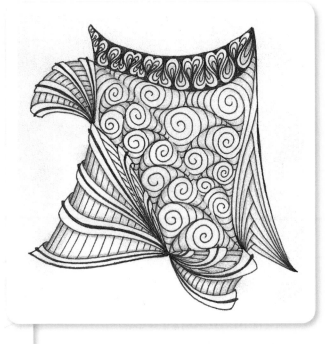

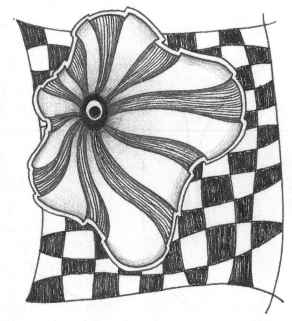

What tips would you give to fellow Zen Doodling artists?

Try to do a little every day and keep those daily pieces on the small side. It will give you a sense of accomplishment to complete something. Don't be discouraged if they don't all come out perfect gems; practice is practice and is valuable even if the result is less than you hoped it would be. That practice will pay off in another piece. Sometimes your preconceived idea of what a piece was supposed to look like spoils your view of what it has become. Put it away and revisit it in a few days or weeks, and you may be able to appreciate it more because you will have forgotten what you intended it to be and can now see it for what it is.

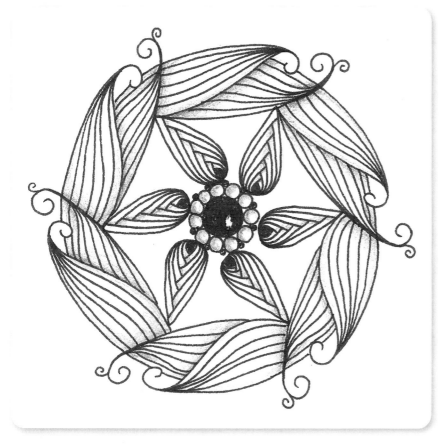

Tell us a Zen Doodling prompt you'd like to share in the book.

One very interesting exercise is to try to use patterns for an entire piece whose names have consecutive letters, spell your name or something similar. This takes the choice of pattern partially out of your hands and challenges you to make whatever patterns come up look good together. Of course, this works only if you know the names of the patterns!

List four things you're inspired by and four things we'd find on your artistic/studio table.

Four things that inspire: other artists' work, the randomness that you find in nature that always seems perfectly balanced and harmonious, the empty margins of my class notes (really, empty margins of anything don't stay empty for long), occasionally patterns found in fabric designs and used on commercial packaging.

Four things in my creative space: a not-too-sharp pencil, a black ink pen, a good white eraser (yes, I use an eraser!) and my current drawing pad or book. It doesn't take much!

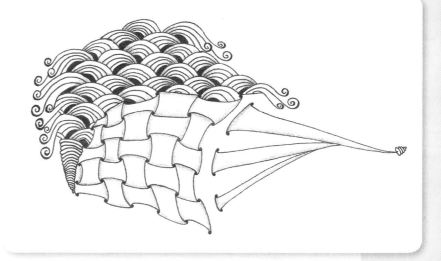

Heather M. Jackson

What inspires you to create your art?

I'm inspired by many things: music, other artists, nature, antiques, books, movies and travel. I keep an inspiration notebook in which I collect patterns and images that I find interesting. These patterns can be found in a multitude of places and things such as fabric, papers, furniture, buildings and nature.

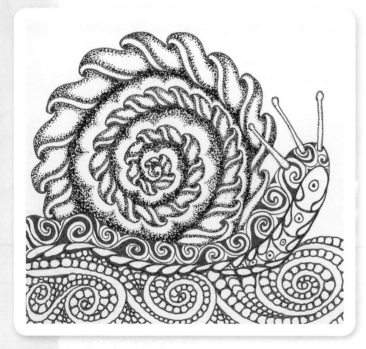

What are your favorite Zen Doodling materials?

I love using Sakura's micron pens, especially the smaller sizes (01 and 005) for detail doodling. Sakura has an assortment of colors and sepia tones as well. I have yet to experiment with doodling in color but want to soon. I'm partial to black-and-white prints. I've been using Strathmore Artist Tiles, 100-lb. (215gsm) bristol with vellum surface pads to create my Zen Doodles on. I also use a Strathmore Mixed-Media 5½" × 8½" (14cm × 22cm) sketch pad as my journal.

Do you have a standard artistic process? If so, what is it?

I have always found that I create my best artwork while listening to classical music, by composers such as Sergey Rachmaninoff, Pyotr Ilich Tchaikovsky, Maurice Ravel and Claude Debussy. The music relaxes me and engages my creative spirit. I also find the tone of the piece of music playing evokes emotions and visual imagery that in turn influence my art.

What tips would you give to fellow Zen Doodling artists?

Listen to relaxing music, doodle and enjoy the process. Don't worry if you make mistakes because there are none; there are just opportunities to learn, experiment and have fun. Keep a sketchbook or journal to record your process. I keep a sketchbook-type journal to note my favorite tangles along with information on their origins for reference. Take pictures or keep a scrapbook of patterns or images you find inspiring.

How did you become an artist? How old were you?

I've always loved creating art for as long as I can remember. When I was growing up, my mom was an amazing artist herself. She inspired my sisters and me to join her in fun crafts and art projects all year round. Some of my fondest memories of childhood are making our own Halloween costumes from scratch and creating handmade Christmas ornaments from ordinary objects such as clothespins, Popsicle sticks, fruit jars, plastic lids, dry macaroni and nuts.

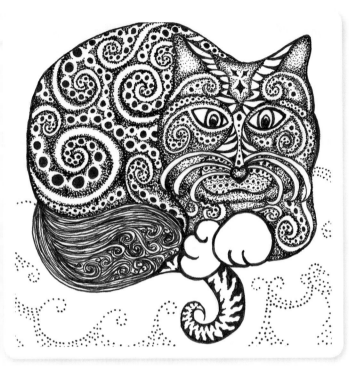

Do you ever give yourself doodling prompts?

A Zen Doodling prompt I give myself is to find interesting patterns and deconstruct them down to their simplest forms and shapes. While deconstructing, you can create your own "step-outs" to produce variations of these patterns. The structural formations of seashells are great sources for discovering patterns. For example, a sand dollar has lots of tiny, delicate details; the closer you look, its intricacies reveal a five-point star shape within its center. The sand dollar is categorized by having a radial pentamerous symmetry throughout its body.

List four things you're inspired by and four things we'd find on your artistic/studio table.

Four inspiring things that immediately come to my mind are a secluded beach house with an ocean-front view, a bookshelf full of children's books, my own children's art and an endless array of classical music to listen to.

I don't officially have a studio table because I do a lot of doodling at night in bed and while I'm waiting for appointments such as in dentist or doctor offices. I do have a doodle bag that I carry with me daily that contains my essentials: pen, paper, a 4" × 6" (10cm × 15cm) plastic photo album that holds my current Zen Doodles, and my go-to sketch pad/journal.

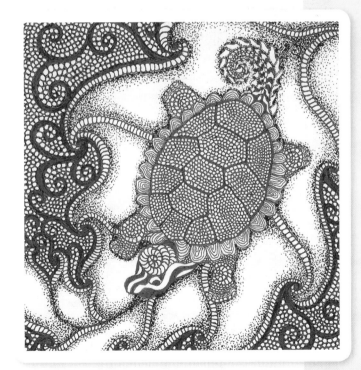

Visit CreateMixedMedia.com/zen-doodle-oodles-of-doodles for bonus materials.

Dr. Lynnita K. Knoch

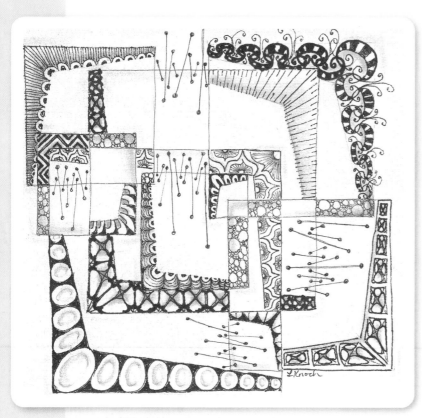

What inspires you to create your art?

I draw inspiration mainly from nature but also from man-made objects. Nature provides an endless resource of surfaces, shapes, patterns, movement and color combinations. Macro-photography presents details that can other-wise be missed. Man-made items, particularly architecture, also provide a variety of ideas for designs, textures and shapes. Lastly, whimsical, fantastical subjects capture my imagination.

Do you have a standard artistic process? If so, what is it?

I draw mainly late in the evening as it relaxes me. An abstract string or a realistic subject, such as an animal, plant or place, gives a place to start a Zen Doodle. Once the string is drawn, the artwork ascertains what type of tangle patterns to add. Yet I do try to balance the type of patterns regarding density of lines, how much of the design is filled and whether the pattern has curved or straight lines.

What tips would you give to fellow Zen Doodling artists?

Zen Doodling is more about the journey than the finished artwork, so relax and enjoy the process. Embrace imperfections as these add uniqueness, charm and whimsy to the overall design. Also, use imperfections as opportunities to create a different path or pattern for the completed doodle. Include shading as it enhances features and movement, transforming the design from a flat, two-dimensional sketch to an exciting piece of art.

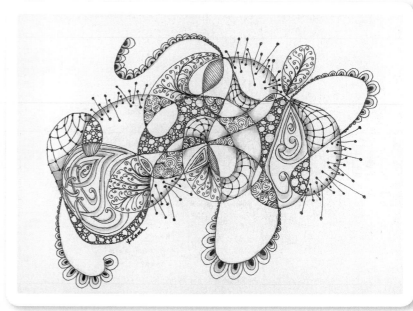

Sign up for our inspiring and free newsletter at CreateMixedMedia.com.

Do you ever give yourself doodling prompts?

When first Zen Doodling, I used prompts such as a die to roll with a corresponding list of numbered tangle patterns. I no longer use prompts except for occasional word prompts when experimenting. Zen Doodling words, such as nouns, adjectives, verbs or even nonsense text or phrases, is a helpful prompt when I am undecided about what direction to take. With a plethora of ideas, I'll need to live well into my hundreds to complete all of them.

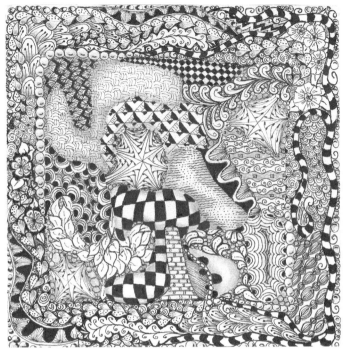

List four things you're inspired by and four things we'd find on your artistic/studio table.

I am inspired by nature (flora, creatures real and imaginary, the ocean, space, weather), architecture, textures (natural and man-made) and prints. Four things you'd find on my studio table would be markers (Prisma-color, Tombow, Sharpies and Copic), paints (Winsor & Newton watercolors, Liquitex acrylic inks, Ranger alcohol inks and Golden and Liquitex acrylics), a variety of papers (Canson mixed-media and illustration papers and Strathmore watercolor and bristol papers) and pencils (Prismacolor colored pencils, Derwent watercolor pencils, Derwent pastel pencils, General charcoal and graphite pencils, and Caran d'Ache neocolor wax pastels).

MELODIE DOWELL

What inspires you to create your art?

Many things. I see things differently since I've been doing art. The sky looks different. Trees look different. I see everything as art. I see things I've never looked at before. I'm more observant. It's amazing where I find art. It's everywhere. And it's contagious. My husband also has picked up this habit of seeing things for me. I carry a camera everywhere I go. Even to stores like Rural King. No, I'm not kidding. I get ideas everywhere.

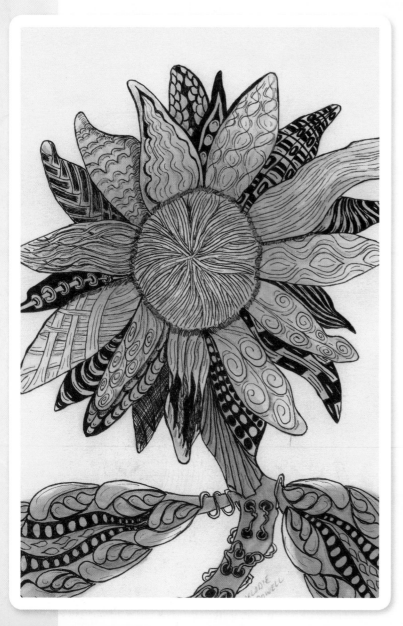

What tips would you give to fellow Zen Doodling artists?

Don't just stick to the common strings or the patterns that everyone else uses. Sit down and start on a piece of paper and let your imagination flow. If nothing happens, go to the books. After you've done a few, you will begin to get more of your own ideas. Don't worry about it. This is supposed to be fun. Don't push yourself. I've found that if I'm not in the mood, I can't do anything.

Also, I always tell anyone who wants to draw to always use a reference. You may think you know what a horse looks like, but when you go to draw it, it sometimes doesn't come out right. The same with a rose or a chicken. Use a reference. You don't have to copy it. Just use it to help you remember where the horse's nostrils are and how the petals go on the rose. I always use a reference.

Do you havea standard artistic process? If so, what is it?

First, I have to get inspired. I tend to like fabric because I love drawing ladies in pretty clothes with neat hair. Otherwise, I'm usually inspired by something I see in a magazine, an animal, a tree or a home-furnishing decoration that has a great curve to it. I also love optical illusions, and these are the hardest things to do.

Then I begin to doodle what inspires me. I cover all but a tiny portion of the image and draw a different small segmant each time, over and over, until it's finished. This process usually always works.

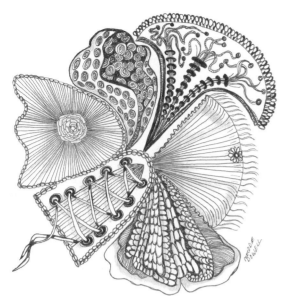

List four things you're inspired by and four things we'd find on your artistic/studio table.

Wow, my studio table is covered with stuff. I'm usually working on a watercolor painting. I just finished a crow and a raven for a show later this summer. I also just finished an acrylic horse on canvas. I have paper towels, drawing materials, a soft eraser, no. 7 pencils, ink pens, plates with watercolors on them, four different lamps pointing at my work space, water bottles, whatever book I happen to be using as reference and the stands to hold it up. All of this is under whatever I've piled on top. My studio is a disaster area. But it works!!

What is your ultimate goal for your art?

Laughing out loud now! At sixty-eight, I want to become rich and famous. However, my second goal is to just keep painting and doodling and having a great time doing it. I love it when something I do comes out right! That's a wonderful feeling. Makes me happy. Makes it all worth it. Life is good.

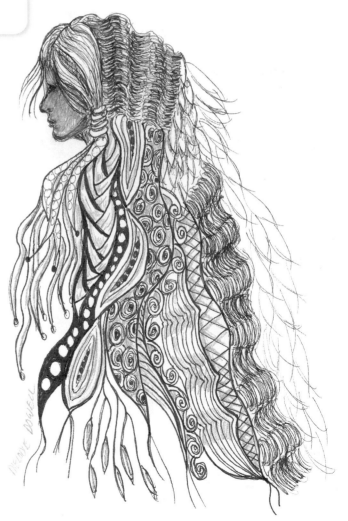

contributors

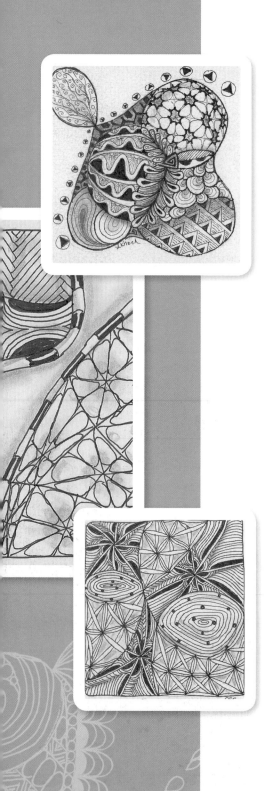

Molly Alexander
13134 S. 178th Ave.
Goodyear, AZ 85338
(602) 206-3349
missmollysdesigns.com
molly@missmollysdesigns.com

Joan Bess

Brenda Campbell
brenda@angelwhispersart.com
angelwhispersart.com

Lisa Chin
SAQA, USDG
somethinglisa@hotmail.com
somethingcleveraboutnothing.
 blogspot.com

Deanna Clifford

Susan Conniry-Beasley
Lakeside, County of San Diego, CA
(619) 977-7132
susan@careforthefuture.org

Katie Crommett
katiecrommett@gmail.com
linecircledot.blogspot.com
katiecrommett.com

Cathy Cusson
716 Pyron Lane
East Ridge, TN 37412
cathycusson54@gmail.com

Patricia Daher
(718) 902-8080
patricia112488@gmail.com
patriciadaher.com

Ruth Dailey
Bay Area Books Arts, Milliande Book-
making Group, Regional Art Assoc.
(831) 247-3335
rodailey@yahoo.com
Scotts Valley Artisan/Art Santa Cruz
facebook.com/inspiredailey
fineartamerica.com/profiles/
 ruth-dailey
etsy.com/your/shops/inspiredailey

Stephanie Melissa Dorsainvil
1603 Banyan Way
Weston, FL 33327
(954) 610-4937
stephanie.dorsainvil@yahoo.com

Melodie Dowell
WSI, Hoosier Salon, Logansport
Art Assoc.
1263 E. County Road 75N
Logansport, IN 46947
(574) 732-1375
vicmeld@comcast.net

Abi Fuller
07854 508307
behance.net/abifuller
abifuller@hotmail.co.uk

Anne Gratton
Johns Creek, GA
amgpaints@gmail.com
amgpaints4u.blogspot.com

Victoria Schultz Grundy
vicabboll@gmail.com

Sally Harrison
Shropshire, UK
07446 764884
mollymeguk@gmail.com
artymollymeg.co.uk

Alice Hendon, CZT
Owner, Artist at The Creator's Leaf
kenoly2000@hotmail.com
thecreatorsleaf.com

Dawn Howell
(731) 300-0281
dhowell9000@yahoo.com
killingthevampire.wordpress.com

Eden M. Hunt
electronmom2000@gmail.com
cutnitip.blogspot.com

Karen Izzi, PhD. CZT
Founder: Philly Area Zentangle
(484) 889-8668
karenizziphd@gmail.com
karenizzi.org

Heather M. Jackson
jacksh3@auburn.edu
flickr.com/heatherjackson3

Kara LC Jones (MotherHenna)
PO Box 306
Vashon Island, WA 98070
(928) 225-5416
kara@motherhenna.com
motherhenna.com

Barbara Kaiser
bkaiserstudio@gmail.com

Dr. Lynnita K. Knoch
AQS, AQG, Art Players
Mixed-Media Group
(480) 529-8086
lynnknoch1961@gmail.com
lynnitaknoch.blogspot.com

Catherine Langsdorf
Hendersonville, NC 28791
(828) 697-3336
c_langsdorf@yahoo.com
alphabeetangles.blogspot.com
facebook.com/CalligraphyLVL

Kathleen McArthur

Curtis McWilliams
(818) 321-5525
Mcwilliams_2@msn.com
Facebook.com/curtismcwilliamsartist

Maria Mercedes
velezmariam@rocketmail.com

Scott Michalski
sjmichalski@gmail.com

Trudy Noordman
Trudio's Studio
Winnipeg, Manitoba
Facebook.com/trudysfunction

Julia Olsen
The Mixie Pixie
themixiepixie@gmail.com
twitter.com/theMixiePixie

Deborah A. Pacé
dpavcreations@gmail.com
dpavcreations.blogspot.com
aartvarkcre8tions.com

Coleen Patrick
SCBWI
coleen@coleenpatrick.com
coleenpatrick.com

Kim Pay
Good Shepherd Art Studio
Calgary, Alberta, Canada
powdermama@gmail.com
powdermama.blogspot.com

Jane Reiter
2211 Hilltop Drive
Lansing, MI 48917-8631
(517) 327-0938
janereiter@sbcglobal.net
tanglewrangler.wordpress.com
retreadart.blogspot.com

Christine Reyes
Berwyn, PA
dsgnermom@yahoo.com
bossycow.net

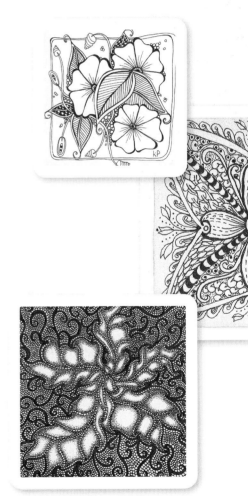

contributors continued

Valentine Werchanowskyj Roché
changeway@earthlink.net
changewaysroche.weebly.com

Annie Sanderson
Fine Art America
mygreekgirl@aol.com

Barbara Simon Sartain
Rocky Cross Studio
rockycrossstudio@gmail.com
rockycrossstudio.blogspot.com

Olga Schrichte

Martha Slavin
Friends of Calligraphy, San Francisco, CA
Nature Printing Society
Collage Artists of America
slavinfamily@hotmail.com
marthaslavin.blogspot.com

Pat Tracz
81 Lancaster Ave.
Malvern, PA 19355
(610) 644-1800
photoctr@comcast.net
thephotographycenter.com

Amanda Trought
Mixed-media artist
realityarts.co.uk
info@realityarts.co.uk
realityarts-creativity.blogspot.com

Candy Taylor Tutt
Coffee Garden
Sacramento, CA
(530) 312-1845
dragoncrone@wavecable.com

Tina Walker
7931 Madison Nan Drive
West Jordan, UT 84081
(614) 551-5853
adogslife13@hotmail.com

Rae Ann Williams
(707) 575-1676
raeann218@comcast.net
raeannwilliams.com

Jay Worling
jay.worling@gmail.com
jworling.com

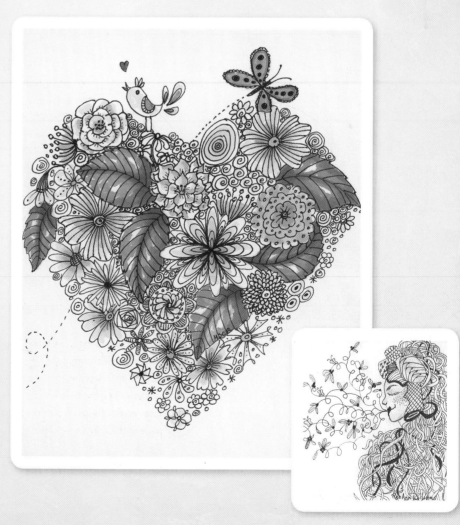

bonus features!

Want more Zen Doodle art? Then visit: CreateMixedMedia.com/zen-doodle-oodles-of-doodles for additional bonus features from our contributing artists. There's everything from additional step-by-steps to more amazing art from our Artists Illuminated contributors—so don't miss out!

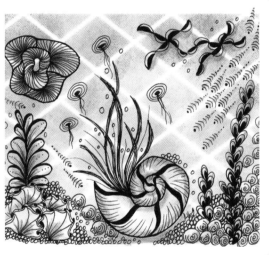

A Note from the Editors

While this is a book about doodling, many of the contributors were inspired by the Zentangle® method of drawing. You can find out more about Zentangle at the Zentangle website.

 zentangle®

zentangle®
www.zentangle.com

The Zentangle method is a way of creating beautiful images from structured patterns. It is fun and relaxing. Almost anyone can use it to create beautiful images. Founded by Rick Roberts and Maria Thomas, the Zentangle method helps increase focus and creativity, provides artistic satisfaction along with an increased sense of personal well-being and is enjoyed all over this world across a wide range of skills, interests and ages. For more information, please visit the Zentangle website.

About Zentangle®:

The name "Zentangle" is a registered trademark of Zentangle Inc.
The red square logo, the terms "Anything is possible one stroke at a time," "Zentomology" and "Certified Zentangle Teacher (CZT)" are registered trademarks of Zentangle Inc.
It is essential that before writing, blogging or creating Zentangle Inspired Art for publication or sale that you refer to the legal page of the Zentangle website.

www.zentangle.com

index

Other fine North Light Books are available from your favorite bookstore, art supply store or online supplier. Visit our website at fwcommunity.com.

18 17 16 15 14 5 4 3 2 1

DISTRIBUTED IN CANADA BY FRASER DIRECT
100 Armstrong Avenue
Georgetown, ON, Canada L7G 5S4
Tel: (905) 877-4411

DISTRIBUTED IN THE U.K. AND EUROPE BY F&W MEDIA INTERNATIONAL LTD
Brunel House, Forde Close, Newton Abbot, TQ12 4PU, UK
Tel: (+44) 1626 323200
Fax: (+44) 1626 323319
Email: enquiries@fwmedia.com

DISTRIBUTED IN AUSTRALIA BY CAPRICORN LINK
P.O. Box 704, S. Windsor NSW, 2756 Australia
Tel: (02) 4560-1600; Fax: (02) 4577 5288
Email: books@capricornlink.com.au

ISBN 13: 9781440336591

Edited by Brittany VanSnepson and Tonia Jenny
Designed by Laura Kagemann
Production coordinated by Jennifer Bass

fw
a content + ecommerce company

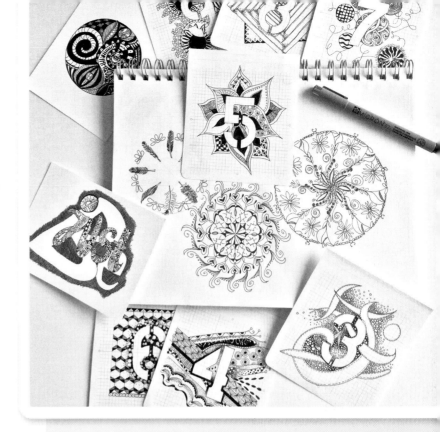

about the editor

Tonia Jenny is the acquisitions editor and senior content developer for North Light Mixed Media. She is passionate about helping other people recognize their gifts and talents and discover ways to bring more meaning into their lives.

A mixed-media artist and jewelry designer herself, Tonia has authored three North Light books: *Duct Tape Discovery Workshop*, *Plexi Class* and *Frame It!*. When she's not busy making jewelry, making art, cooking, stitching, reading or exploring new ways of looking at the world, you can find her on her bicycle or on Instagram.

metric conversion chart

To convert	to	multiply by
Inches	Centimeters	2.54
Centimeters	Inches	0.4
Feet	Centimeters	30.5
Centimeters	Feet	0.03
Yards	Meters	0.9
Meters	Yards	1.1